IMAGES
of America

OVERHILLS

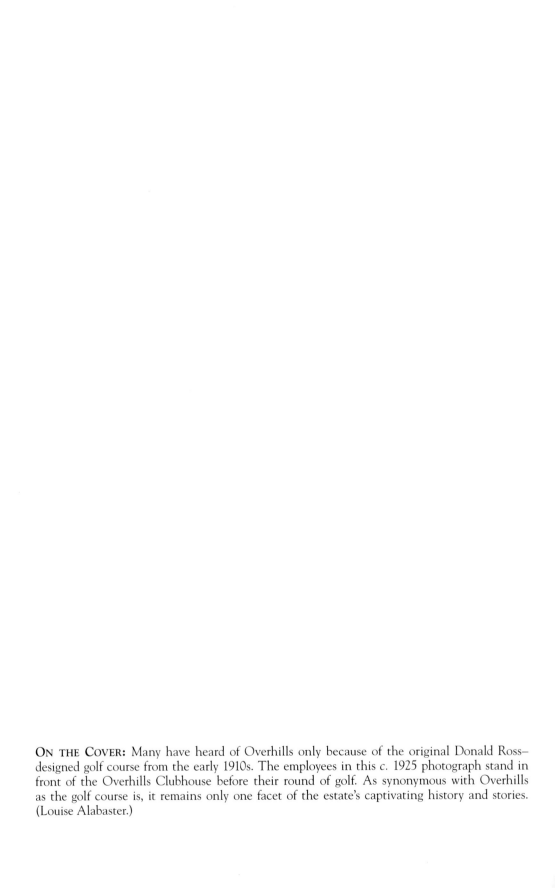

ON THE COVER: Many have heard of Overhills only because of the original Donald Ross–designed golf course from the early 1910s. The employees in this c. 1925 photograph stand in front of the Overhills Clubhouse before their round of golf. As synonymous with Overhills as the golf course is, it remains only one facet of the estate's captivating history and stories. (Louise Alabaster.)

IMAGES
of America
OVERHILLS

Jeffrey D. Irwin and Kaitlin O'Shea

ARCADIA
PUBLISHING

Copyright © 2008 by Jeffrey D. Irwin and Kaitlin O'Shea
ISBN 978-0-7385-5433-4

Published by Arcadia Publishing
Charleston SC, Chicago IL, Portsmouth NH, San Francisco CA

Printed in the United States of America

Library of Congress Catalog Card Number: 2008923567

For all general information contact Arcadia Publishing at:
Telephone 843-853-2070
Fax 843-853-0044
E-mail sales@arcadiapublishing.com
For customer service and orders:
Toll-Free 1-888-313-2665

Visit us on the Internet at www.arcadiapublishing.com

To those who once knew a place called Overhills, North Carolina.

CONTENTS

ACKNOWLEDGMENTS

We owe sincere thanks to many people. First and foremost, thank you to the photograph and document donors: David Alabaster; Louise Alabaster; Walter Edward Bruce Jr. (noted as W. E. Bruce Jr.); Ann Collins; Betty Deere; Ann Elliman; Christopher Elliman; Isabel Elmer; Ken Grayson; Sandy Hemingway; Brenda Mathews Hollenberg; Martye Kent; Kathleen Mortimer; Patricia Penny; Bruce Strauch; Dennis Washington; Fort Bragg; Greensboro Historical Museum, Inc.; North Carolina State Archives (noted as NC Archives); and the North Carolina State Historic Preservation Office (noted as NC SHPO).

Thank you all who have previously researched Overhills (see bibliography). Thank you to Kristin Landau for her thorough chapter reviews. Thank you to our editor, Maggie Bullwinkel, for her patience and assistance. Thank you to our families and friends, who provided invaluable support and the endurance to listen to our constant Overhills conversations. Without you, we would not have finished in one piece.

INTRODUCTION

The story of Overhills begins with the passing of a vast family farm and the subsequent entrance of newcomers seeking a sportsmen's paradise. In the early 20th century, successive groups of investors and hunters carved a rustic country club from the old turpentine country of the North Carolina Sandhills. Northern capitalists and financiers found their way to this unique region of the rural South, discovering a wealth of solitude, open land, and sporting opportunities. In its heyday, the club would feature bird hunting, foxhunting, golf, and polo for members and guests.

The land itself seemed to offer little promise. Historically, the Sandhills region earned pejorative names such as the Pine Barrens because of poor soil conditions and the dominant southern pine. Located in the Cape Fear River basin on the western edge of the Coastal Plain, the Sandhills area is characterized by deep, sterile sands from ancient deltas that have since been eroded, dissected, and windblown to form a hilly landscape. Tall pines and a thick wiregrass ground cover create a sparse but beautiful forest, which would later intrigue and lure hunters to this area.

The 19th-century economy of this region focused on the longleaf pine tree. By the mid-19th century, the naval stores industry was king, and settlers relied on lucrative products derived from the longleaf pine, including tar, pitch, and turpentine. At the dawn of the 20th century, the Sandhills faced significant changes in land use and ownership as the area forests were depleted and the naval stores industry moved south. Newcomers to the area seized an opportunity in the land; Northern businessmen and bankers took advantage of the inexpensive and undeveloped land, in some cases displacing local families and their agrarian lifestyles. In the place of subsistence farming and turpentine orchards, the western portion of the Sandhills developed into health resort towns such as Pinehurst and Southern Pines. The central Sandhills became a large field artillery reservation for the U.S. Army. In the northern Sandhills, Overhills was created.

The land base for Overhills was the legacy of a prominent Sandhills family. In the early 19th century, the McDiarmids, of Highland Scot descent, established a prosperous turpentine plantation near Manchester. Following the death of Daniel McDiarmid, economic hardship forced the sale of the family land at auction in 1892, and a series of land acquisitions led first to a hunt club, then a country club.

The Consolidated Lumber Company was first. This timbering operation, headed by John Gossler of Philadephia, held the old McDiarmid land for nine years. Englishman William Johnston, owner of a shipping company in Liverpool, then purchased the timbered property, envisioning a hunting preserve. Although Johnston's preserve did not materialize under his ownership, the earliest hunts, including those led by a Guilford County sheriff named James Francis Jordan, likely occurred during the lumber company days. In 1906, Gen. John Gill, a capitalist from Baltimore, Maryland, and James T. Woodward, a banker from New York, purchased the property to form the Croatan Club of Manchester. This hunting club, now consisting of more than 20,000 acres on the old McDiarmid property, served as the predecessor to Overhills. A group of investors from various financial institutions, as well as industrialist William DuPont, invested in the club.

The early players in these transactions included a host of individuals, few of whom were North Carolina natives. Beginning with the lumber dealers who bought the McDiarmid land, an Englishman who saw potential for a game preserve, and a party of investors who created the Croatan Club, a pattern was established where people from distant places, primarily wealthy

Northerners, invested in land for recreational, if not capitalistic, ventures. However, by 1911, one North Carolinian became involved, setting Overhills on a fateful path.

James Francis Jordan, a robust character from Guilford County, a former sheriff and a highly respected hunt guide and sportsman, had been leading hunts and investing in the Sandhills since the early 1900s. Prior to Overhills, Jordan had been active in the Sandhills as early as 1903 and was integral in the formation of another hunt club, the Buckthorn Hunt Lodge, located just south of the Lower Little River, which served as Overhills' southern boundary. After years of involvement with hunt clubs in the Piedmont, Jordan found potential in the Sandhills. His early Sandhills foxhunts were somewhat primitive affairs. North Carolina lawyer Aubrey Brooks described a party of men, hounds, and horses riding a "jerkwater passenger train" to camp in the Sandhills to hunt for a week.

By 1911, Jordan had developed a relationship with William Kent, at the time serving as a newly elected California congressman. An acquaintance of John Muir, Kent was a conservationist with a populist platform. In 1911, Kent and Jordan purchased the Croatan Club and formed the Kent-Jordan Company, which would formally launch Overhills as a country club. A passionate sportsman himself and one of several Yale graduates to enjoy and influence Overhills, Kent brought to the partnership a love for the outdoors, as well as capital and real estate acumen.

At the time Kent and Jordan became partners, Overhills was little more than timbered land with some old agricultural fields; few structures stood on the property. The Kent-Jordan Company initiated additions almost immediately, building facilities such as a clubhouse, golf course, dog kennels, and a barn. Their ideas for development ranged from a community or town with mixed recreational, residential, and agricultural land use—a kind of arcadian utopia—to a major club with a grand hotel. The Overhills Country Club, their final, more humble statement, officially opened for the 1913–1914 winter season.

The critical involvement of the Kent-Jordan Company was short-lived. Jordan died unexpectedly in 1919. Kent left the venture for unknown reasons, likely related to his return to California after congressional service. After their departure, several individuals who had come to know the club began to influence Overhills. One in particular became the driving force.

Along with noted diplomat and industrialist William Averell Harriman, Percy A. Rockefeller first visited Overhills in 1916. The nephew of John D. Rockefeller, Percy developed a strong interest in the estate, ultimately becoming the primary financier and leading voice in the estate's development. Rockefeller funded the acquisition of additional land, built his own winter residence at the estate, and brought his passion of foxhunting to Overhills, constructing an elaborate hunting complex. Rockefeller and Harriman became the steering parties in management after Jordan's and Kent's abrupt departures. The Overhills Land Company, headed by Rockefeller and Harriman, formed in 1921 for the purpose of managing the estate. Rockefeller and Harriman became the primary shareholders after Jordan's and Kent's departures. By the early 1930s, Rockefeller would become the principal owner and director of Overhills.

The 1920s were the most spectacular decade at Overhills. Country club members, their families, and guests traveled by rail on an overnight trip from New York City. The club featured golf, tennis, and horseback riding for everyone. Hunting, the old tradition of Overhills, continued to thrive. Upland game birds were especially popular among guests and members, for whom pedigreed pointers and setters were kenneled. Daily guided hunts were led through the pine forest to pea patches or agricultural fields. Polo ponies were brought by rail and stabled in the polo barn. Practices and matches were held on site. For visitors, a typical day's activities may have included golf in the morning and clay pigeon shooting in the afternoon or bird hunting in the morning followed by a round of golf. The Clubhouse was at its busiest at this time. Often it was a center of activity for guests planning activities, relishing a meal, or enjoying the evening with friends. The estate continued to grow, peaking at around 41,000 acres in 1930.

At the same time that Overhills experienced its premier years as a country club, it was also a working farm. Tenant farms were spread across the estate, most on the edges of the vast property, some within reach of hunting parties. Cotton was the primary cash crop, followed by

some within reach of hunting parties. Cotton was the primary cash crop, followed by corn, and tobacco, rye, wheat, sweet potatoes, Irish potatoes, and garden produce were grown as well. Scientific farming was practiced at Long Valley Farm. The Lindley Nursery Company of Greensboro maintained a satellite operation at Overhills. Livestock were kept and a dairy was also operated.

Throughout its history, Overhills comprised an eclectic social scene. Wealthy capitalists and bankers drove the sporting interests. Directors of large corporations and men of massive wealth came to Overhills to hunt. Their wives, children, business partners, and friends came as well. Ultimately, the estate became synonymous with one of the most powerful and storied families in modern American history. Meanwhile, across the sprawling acreage were numerous more common folk. Houses and workers' cottages were scattered throughout the property, persisting for much of Overhills history. Employees, including tenant farmers and their families, lived in these homes, often for multiple decades and generations. While the proprietors and guests of Overhills were seldom native Carolinians, the employees they encountered in the dining rooms of the clubhouses and cottages, the stables and kennels, the train station, the post office, and the farms were local. Ethnically diverse, these folks called Overhills home. They lived on the estate year-round, enjoying the off-season benefits of a seemingly endless private land base.

Like much of the country, the Great Depression brought change to Overhills. Diminished interest and activity, combined with organizational changes and the deaths of the primary benefactors, resulted in the end of the hunt and country club days. Percy Rockefeller, who had personally financed much of Overhills' operations for a number of years, died in 1934, and his wife, Isabel, passed away in 1936. The estate of Percy Rockefeller was settled in 1938. The Overhills Land Company was dissolved, with the shares being purchased by Overhills Farms, Inc. Shares in the latter would be held by Percy and Isabel's children, led by their only son, Avery. From this point forward, Overhills would be a family retreat, a private vacation destination that retained the traditional winter schedule for the family. Farming operations continued, and employees worked and lived at Overhills year-round. The legacy of Rockefeller and Harriman would fade quickly as polo was no longer played, foxhunting ended abruptly, and bird hunting declined. By the mid-1950s, the old Clubhouse and Percy's cottage—the Covert—would be demolished. A more subdued collection of ranch-style houses designed for the growing family ringed the hill.

Under the leadership of Avery Rockefeller and Supt. William Bryan Bruce, Overhills took on a new identity as a family retreat and farming operation. Several generations of Percy and Isabel Rockefeller's descendents would call Overhills their own. By the 1990s, a lack of a common vision for Overhills led to an uncertain future. Conversations with the estate's long-term neighbor, the U.S. Army, led to the final chapter. Some 10,500 acres of land were sold to the army in 1997, and Overhills became a part of Fort Bragg.

One

SENSE OF PLACE

When first established as a hunt club, Overhills was by its nature a large, rambling country estate. These privately owned acres lay in plain sight of the surrounding communities, yet signs of residents were hidden miles down the sand roads. Visitors approached Overhills by rail or automobile. Traveling down a seemingly uninhabited dirt road, they would have encountered Overhills' core area, the Hill, sitting on a high, level ridge near the railroad line and lake. Dirt trails connected various parts of the estate, reaching hunt kennels, stables, and farm fields.

Images in this chapter serve as a visual tour, beginning on the Hill and traveling down to the areas near the railroad tracks, to the lake, the Circus, and finally across a state road to the farming section of Overhills.

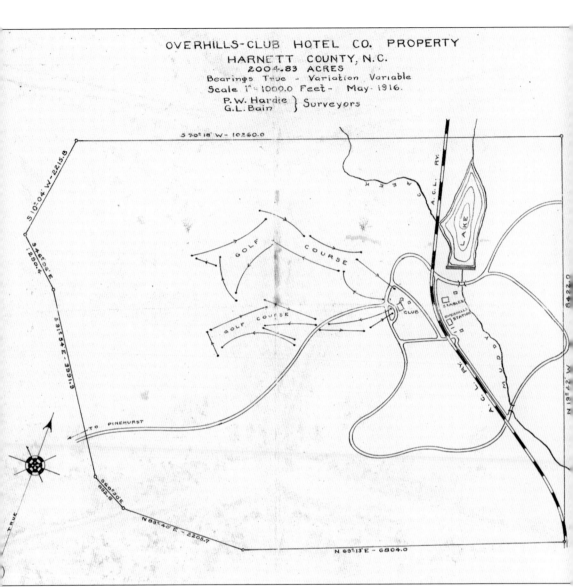

Surveyed in 1916 by P. W. Hardie of Greensboro, North Carolina, this is an early map of Overhills under the name "Overhills–Club Hotel Co. Property." By the time this map was completed, the Overhills Country Club had operated for three winter seasons under Kent-Jordan Company ownership. Friends of James Francis Jordan and William Kent visited each winter, including such wealthy businessmen as Percy Avery Rockefeller and William Averell Harriman. The map shows the amenities awaiting the club members, guests, and their families: stables, the 18-hole golf course, a train station, tennis courts, and dog kennels. Eventually, this area would become the core of Overhills, and it focused on recreation and lodging. Later Overhills stockholders would build additional residences near the Clubhouse. The Atlantic Coast Line Railroad, Overhills Lake, Muddy Creek, and Pinehurst Road are also mapped. (NC Archives.)

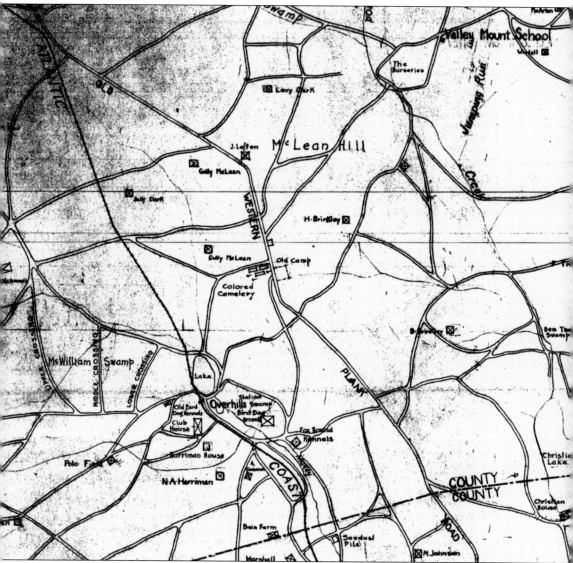

This *c.* 1925 map showing the rural setting of southern Harnett and northern Cumberland Counties illustrates the location of Overhills along with surrounding landowners, local landmarks, and roads. The Clubhouse and Harriman house mark the Hill area. Nearby are dog kennels, the lake, and the polo field. Many of the residences are those of Overhills employees or tenant farmers. In the upper right is the Lindley Nursery and Valley Mount School, both in the easternmost section of Overhills. The Atlantic Coast Line and the Old Western Plank Road cut through the estate. The latter, which would become a modern highway (Route 87), is the largest regional road passing through Overhills. This road divided Overhills into an eastern agricultural side and a western recreational half. The dirt road leading southwest, south of the polo field, ran to Pinehurst. In the lower right, the Christian Lake and house mark the home of Robert Wall Christian, a local businessman and scientific farmer, who often visited Overhills as a guest and friend. Christian's land was known as Long Valley Farm. Following Christian's death in 1927, Long Valley became part of Overhills for a brief period. It was owned for most of the 20th century by James Stillman Rockefeller. (Fort Bragg.)

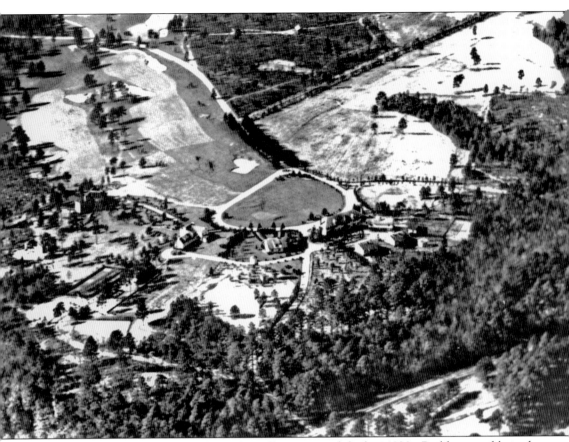

A bird's-eye view of Overhills shows the Hill area around the late 1930s. Buildings visible in the photograph are, from left to right, Croatan Lodge, Covert Cottage, the Alabaster house (behind Covert), Harriman Cottage, the Clubhouse, and the servants' quarters behind the Clubhouse. Formal landscaping is beginning to mature and would eventually demarcate individual houses from one another. The golf course occupies most of the area in the photograph. The pine allee, along which players rode ponies to the polo field, is visible as a linear feature in the upper right. In the lower right portion of the photograph, the railroad tracks form a slightly curved line, recognizable here as a path through the trees. Below the railroad tracks, the cleared area included the passenger station, the riding stables, the polo barn, and the freight station. (NC Archives.)

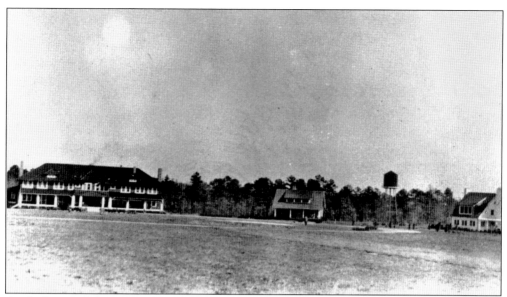

At the heart of the *c.* 1920 Overhills Country Club sat three buildings: the Clubhouse (left), Harriman Cottage (center), and Covert Cottage (right), each oriented toward the golf course. Behind the Clubhouse were two workers' cottages. Referred to here as "the Hill," this area served as lodging for guests and eventually for Percy and Isabel Rockefeller's children and their families. (NC Archives.)

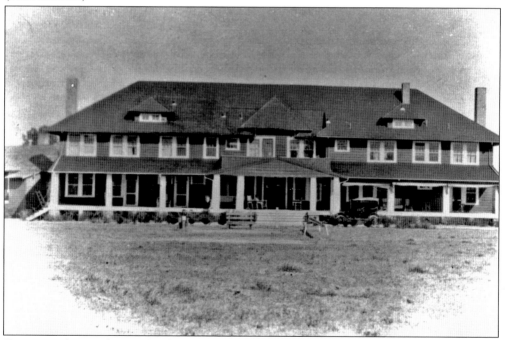

Constructed around 1913 for the Kent-Jordan Company as the Clubhouse for the Overhills Country Club, this building was the main lodge welcoming visitors. Members of the country club and shooting syndicate, their friends, and their families stayed here. The Clubhouse was the center of activity well into the 1930s, hosting guests, Christmas parties, square dances, and wedding receptions. (NC Archives.)

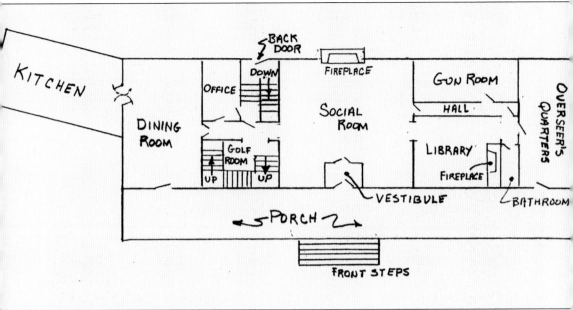

Guests at the Clubhouse could spend an evening in the library, clean their guns in the gun room, enjoy a meal in the dining room, or relax in the living room near the fireplace, over which loomed a giant moose head. Upstairs, 14 guest rooms each had a private bath. A common gathering room opened to the sun porch. The rooms, numbered 1 through 15 (skipping 13), were furnished with beds, dressers, blankets, and towels embroidered with "Overhills." In the lower right wing, the superintendent lived with his family. The guest book sat in the vestibule, with the first entry dated 1913 and the last dated 1937. After the late 1930s, guests rarely stayed here. Avery Rockefeller ordered its demolition around 1946 as a result of the high cost of maintenance and the limited use it received. (Sketch from memory, W. E. Bruce Jr.)

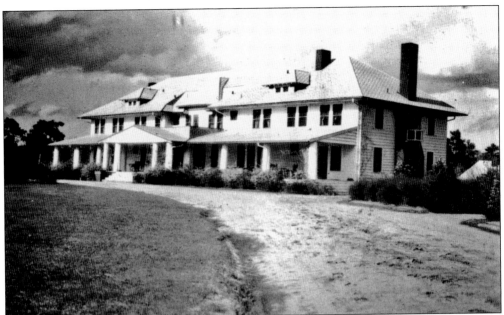

While its architect is unknown, the Overhills Clubhouse was a craftsman/prairie-style building with distinctive, skinned pole columns on a broad porch. This c. 1930 photograph shows the later white appearance, as well as more mature landscaping. On the right, the roof to one of the servants' quarters is visible. (Louise Alabaster.)

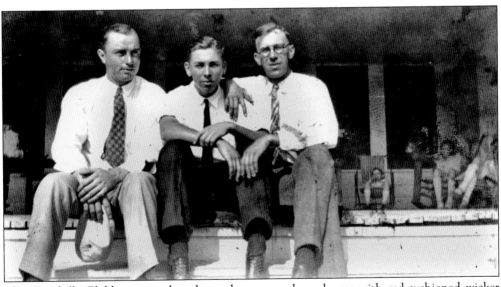

The Overhills Clubhouse porch welcomed guests and employees with red-cushioned wicker furniture and ample shade. Southern magnolia trees grew to skirt the porch, standing as a testimony to the Clubhouse long after its removal. In this photograph, three employees sit on the porch steps in the mid-1920s. From left to right, they are unidentified, Bennie Bruce, and Walter Edward Bruce Sr. (W. E. Bruce Jr.)

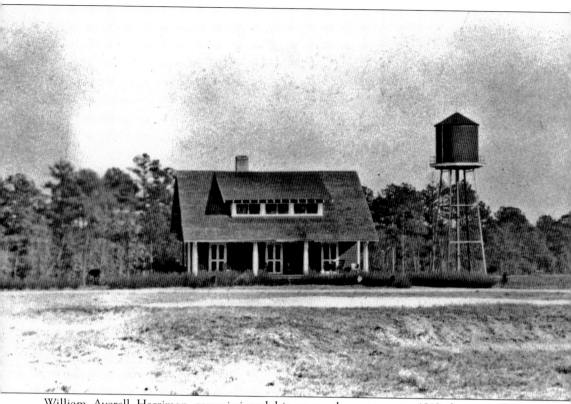

William Averell Harriman commissioned his namesake cottage in 1918, by an unknown architect. The house is a traditional one-and-one-half-story vernacular bungalow. The skinned pole columns are similar to those used by the Clubhouse, servants' quarters, and passenger station. Harriman, his family, and guests often stayed here during the 1920s and early 1930s; afterward it became Overhills property. Upon impending demolition of the Clubhouse, around 1946, the superintendent, William Bryan Bruce, and his family moved to the Harriman house. They lived here for the remainder of their tenure at Overhills. In the 1960s, a one-room addition and a small rear porch were constructed on the north side. Other than the addition and screening the porch, the house retained its original construction elements such as hardwood floors and bead-board walls. In the mid-20th century, the water tower was relocated above the Circus. (NC Archives.)

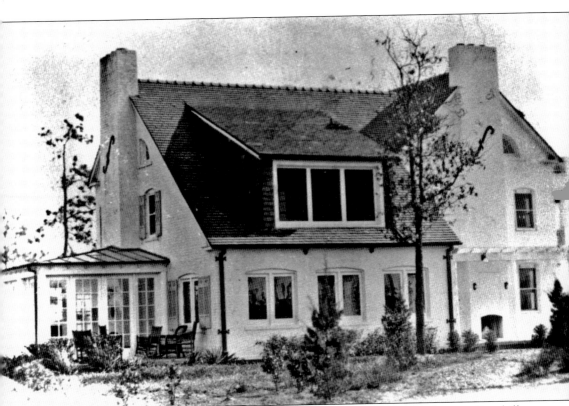

Percy Rockefeller commissioned the Covert Cottage as his own personal residence at Overhills, taking the name from the foxhunting term for the foxes' refuge from the chase. Cross and Cross Architects of New York designed the terra-cotta, brick, and concrete house in 1917. They amended the design later that year and completed construction within the next few years, by 1921. Constructed like a skyscraper with steel and poured concrete, the house was fireproof; family lore credits this to Rockefeller's concern with a house fire he witnessed as a child. The above c. 1925 photograph shows the front of Covert Cottage, which overlooked the golf course. Architecturally, it is an example of a restrained Colonial style with visible Tudor and cottage elements. Although it was the largest residence at Overhills, the Covert represented a much more casual atmosphere and appearance than the family's mansion, Owenoke, in Greenwich, Connecticut. (NC Archives.)

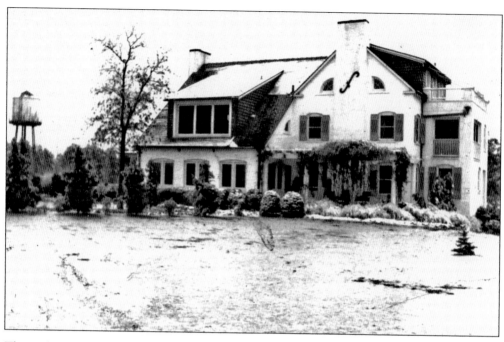

These photographs show Covert Cottage around 1925, draped in snow. Above is the front of the house, west elevation, and below is the side, north elevation. The Covert blueprints show a cellar and three floors of living space. On the first floor, there were two bedrooms, two sleeping porches, one bathroom, a living room, kitchen, pantry, and a kitchen porch, as well as numerous closets. The second floor had four bedrooms, each with its own fireplace, three bathrooms, and one sleeping porch. Two bedrooms with a shared bath, a roofless sleeping porch, and trunk storage space were on the third floor. (Both, Louise Alabaster.)

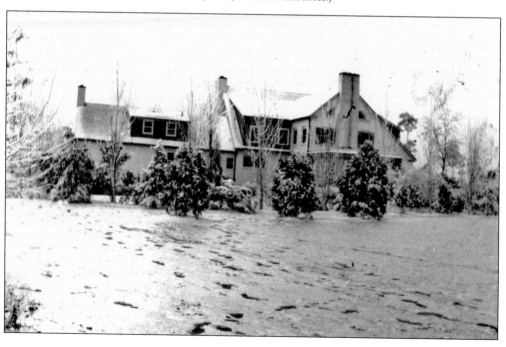

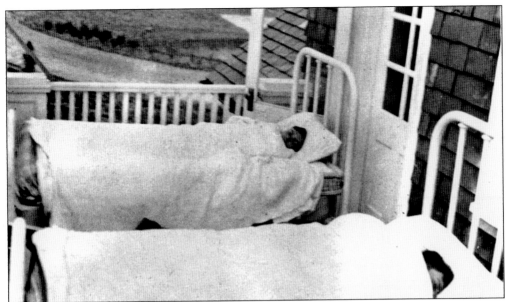

Sleeping in the winter, pine-scented air was considered beneficial to one's health in the 1920s and 1930s. Houses on Overhills, including Croatan Lodge, Covert Cottage, and Harriman Cottage, featured sleeping porches for this reason. This photograph shows an open sleeping porch on the third floor of Covert Cottage. (NC Archives.)

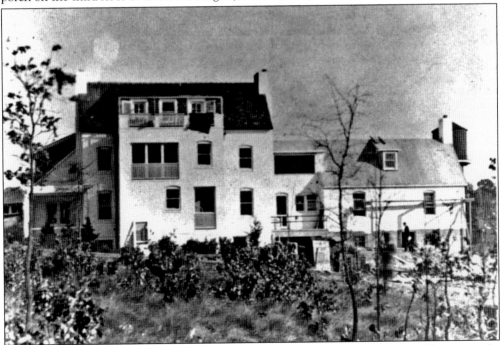

After Percy Rockefeller's death in 1934, his family used the house only as overflow space for large family visits. Otherwise, it was used for storage; a 1940 inventory lists silverware and linens still in the house. In 1954, Avery Rockefeller ordered the house to be demolished because of its infrequent use and rising maintenance costs. This photograph shows the south elevation in the mid-1920s. (NC Archives.)

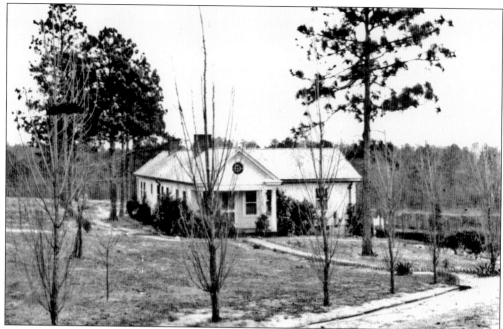

The Alabaster house was built as the residence of Percy Rockefeller's personal valet, Albert Alabaster, and his family. A landscaped footpath connected the butler's house to the rear of Covert Cottage. This craftsman-style bungalow, complete with a wine cellar in the basement, was unlike any of the other houses on the Hill. After the Alabaster family left Overhills, around the time of Percy Rockefeller's death in 1934, the McCoy family lived here. By the 1950s, the house sat vacant and overgrown, eventually earning a reputation as being haunted. The above photograph dates to 1924 and the photograph below was taken around 1930. The house stood until the 1960s. (Both, Louise Alabaster.)

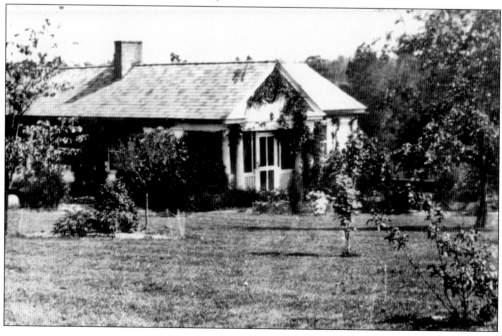

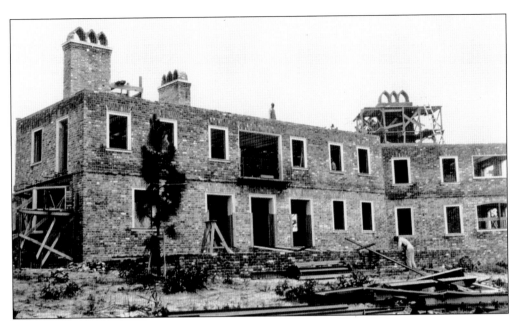

In 1928, Percy and Isabel Rockefeller commissioned the architectural firm Hiss and Weeks of New York City to design Croatan Lodge. Family legend attributes that its purpose was to provide needed space for the growing family, including the grandchildren, away from the privacy of Percy's Covert Cottage. Like the Covert, this building would be an architectural statement at Overhills, created in Colonial Revival style. It, too, was built with steel and poured concrete to decrease the risk of fire. Historic bricks and ceramic roof tiles were salvaged from deconstructed buildings in Charleston, South Carolina. The above July 1928 photograph shows the view from the south. The photograph below shows construction progress and the steel I-beam roof structure. Named in honor of the estate's early history as the Croatan Club, Croatan Lodge would survive throughout Overhills history. (Both, Christopher Elliman.)

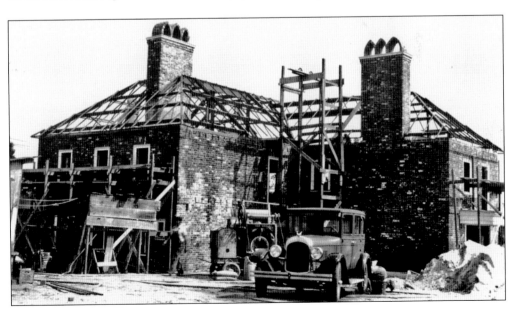

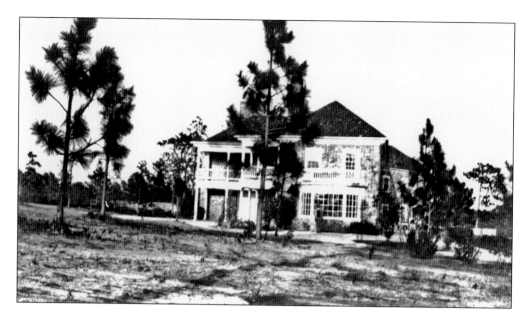

In designing Croatan Lodge as a family retreat, emphasis was placed on sleeping quarters. Croatan featured five bedrooms and five sleeping porches. A large living room served as a popular evening gathering spot for family and guests. A small dining room connected to the kitchen. There was one bedroom and a sleeping porch on the first floor as well. Three small bedrooms for nannies, the nursery, and two bedrooms with sleeping porches occupied the second floor. The third floor was unique: a dormitory-style room with an open-air porch and separate boys' and girls' baths. Some of Ethel Peterson's most beloved paintings adorned the children's bathroom walls. Both photographs show Croatan Lodge, around 1930 above and around 1940 below. (Above, W. E. Bruce Jr.; below, Christopher Elliman.)

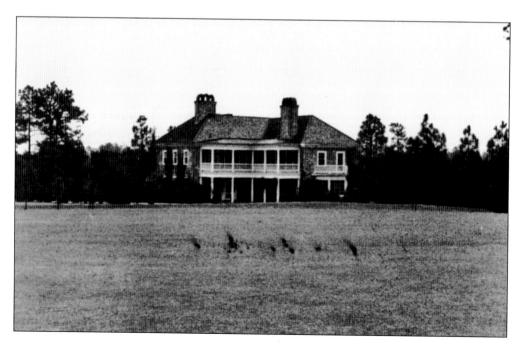

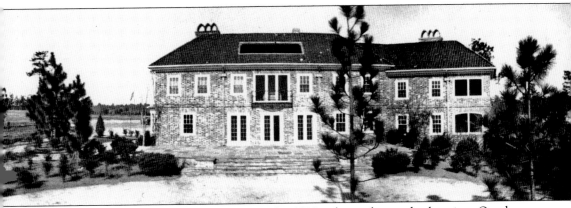

This photograph of Croatan Lodge, taken in the 1930s, shows the south elevation. On the far right of the first and second floors and on the center roof, sleeping porches are visible, recognizable by the open spaces. Two of the original three bays of French doors that opened to the stone-flagged patio from the spacious living room were eventually altered to picture windows. A bay window overlooks the golf course, which is to the left in this photograph. The arched chimney toppers and tile roof both represent a Spanish Colonial influence. All of the open sleeping porches had concrete floors with drains for rainwater; the open bays were enclosed in the second half of the 20th century. From this vantage point, the matching Croatan Garage sits downhill to the right. (Sandy Hemingway.)

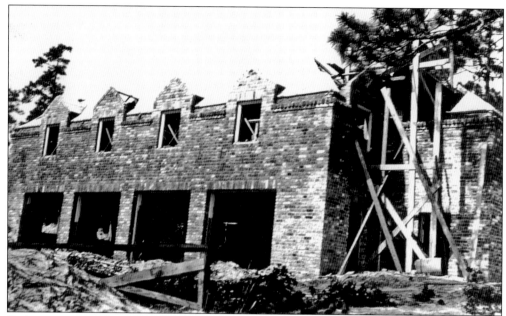

Built contemporarily with the same bricks and roof tiles as the lodge, Croatan Garage mirrors the Croatan Lodge's architectural style. The first floor served as the garage, with room for four period vehicles. The second floor contained a small, linear-plan apartment with several rooms. Entrance to the second floor could be accessed on the right side of the building. Employees and their families lived in the apartment, though in the latter decades, it served as storage. The above photograph was taken during its construction on September 11, 1928. This structure was the only multi-vehicle garage ever constructed on the Overhills property. Below, the photograph shows the appearance of the garage in the latter decades of Overhills' history. (Above, Christopher Elliman; below, Fort Bragg.)

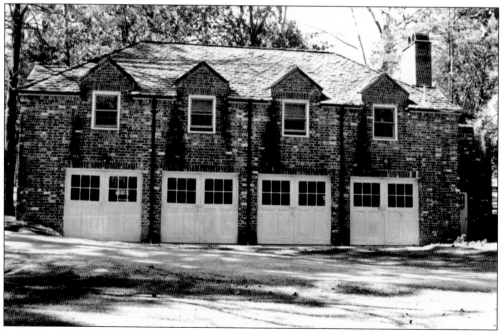

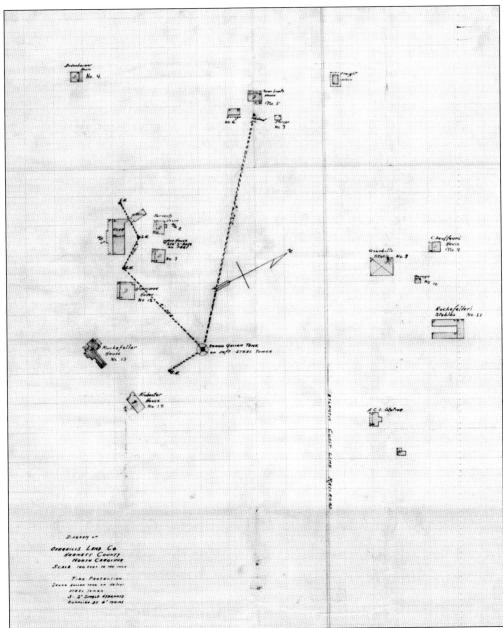

A 1927 insurance map depicts the locations of the main buildings on the Hill, south of the railroad tracks (on the left). Buildings to the northwest of the Hill include two workers' cottages and the freight station. The straight line dividing the right third of the map represents the Atlantic Coast Line Railroad. North and northeast of the railroad tracks are the polo barn, the chauffeur's house (behind the polo barn), the riding stables, the passenger station, and the small log cabin behind it. The central dot with lines emanating outward represents the water tower, as well as pipes to fire hydrants and pump houses. Buildings that appear here, starting at the bottom, are the Alabaster house, Covert Cottage, Harriman Cottage, the Clubhouse, and the servants' quarters (to the right of the club). Insurance coverage of the buildings often depended on who owned them, such as Percy Rockefeller or the Overhills Land Company. (Fort Bragg.)

From the front porches of the houses on the Hill, the view included the golf course, but from the rear, one would see the above scene c. 1930. Narrow sand roads led downhill through a stand of mature longleaf, beyond which lay the railroad line and a clearing where the passenger station (faintly visible here), worker's cottage, riding stables, and polo barn stood. (Sandy Hemingway.)

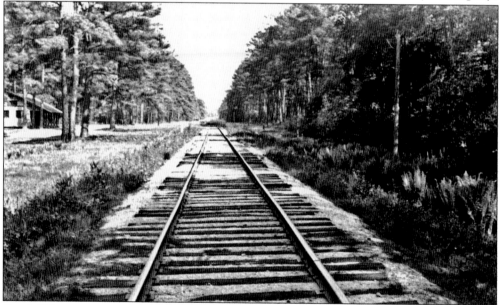

Overhills' origin is partly attributable to a spur of the Atlantic Coast Line Railroad that connected Fayetteville and Greensboro, North Carolina. This rail line, illustrated here in the 1950s, brought the early hunting parties of sportsmen from Greensboro. Gen. John Gill, president of the Cape Fear and Yadkin Valley Railroad, a precursor to the Atlantic Coast Line, was an investor in the Croatan Club. (W. E. Bruce Jr.)

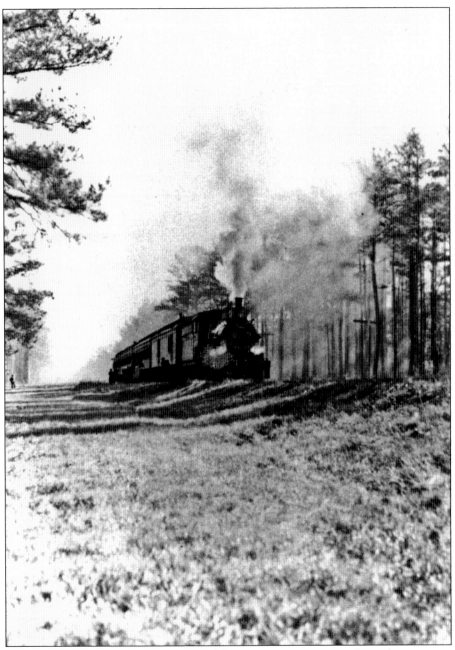

By the time Overhills became a country club, visitors were arriving by rail, as seen in the photograph above, where the train from Fayetteville is being unloaded at the passenger station. A silhouette of a person standing alone is visible on the left. Just out of sight to the left is the passenger station. From here, visitors to Overhills would likely be taken to the hill area, where they would find accommodations at the Clubhouse or one of the cottages. By the 1940s, the train no longer provided passenger service to Overhills but continued to deliver freight, such as coal via the Railway Express, as well as the U.S. mail. By 1968, the freight service had stopped as well, and the tracks were soon removed. The old railroad bed remained visible for decades thereafter. (NC Archives.)

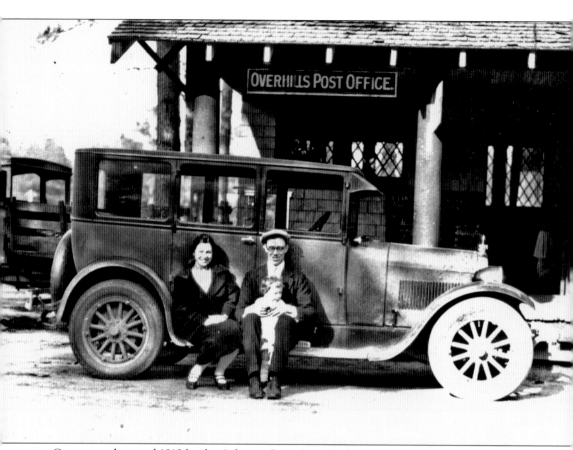

Constructed around 1913 by the Atlantic Coast Line Railroad Company, this building served as the Overhills Passenger Station, train ticketing office, post office, and telegraph office. Located down from the Hill, just east of and facing the railroad tracks, the passenger station was part of a complex of buildings that included the riding stables, polo barn and cottage, a small log cabin, and a freight depot. The station would eventually be adapted into a house for employees and would remain in use as a residence throughout Overhills' history. Architecturally, the building featured a craftsman style with diamond-shaped lighted windows and skinned pole columns that matched several other early buildings at Overhills. In this *c.* 1924 photograph are Sabra Coble, wife of employee Charles "Chub" Coble; employee Walter Edward Bruce Sr.; and Katherine, daughter of Charles and Sabra. (W. E. Bruce Jr.)

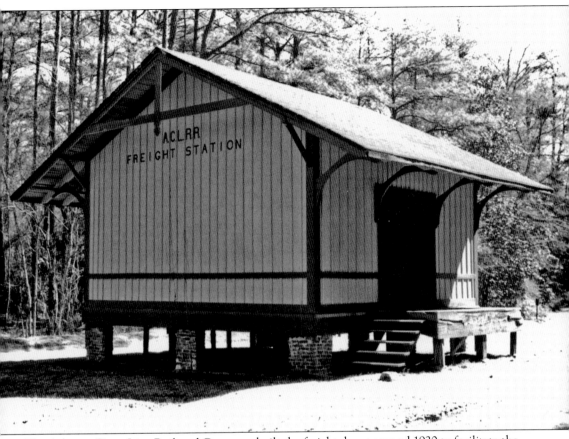

The Atlantic Coast Line Railroad Company built the freight depot around 1920 to facilitate the shipping and receiving of coal, turpentine products, and nursery stock. Lindley Nursery often shipped plants and shrubbery to Greensboro, North Carolina. Employees of the nursery would have to transport the stock via wagon or automobile on the dirt road, aptly named Nursery Road. The freight station is a frame structure with board-and-batten siding, resting on high brick piers in order to be at level height with the freight cars. Both sides are simply adorned with the words "A.C.L.R.R. Freight Station," which remained even after the railroad no longer owned the structure. Once the tracks were removed, Overhills used the freight station as storage for fertilizer. Formerly, a side track sat adjacent to the building, which allowed for the loading and unloading of shipments. (Fort Bragg.)

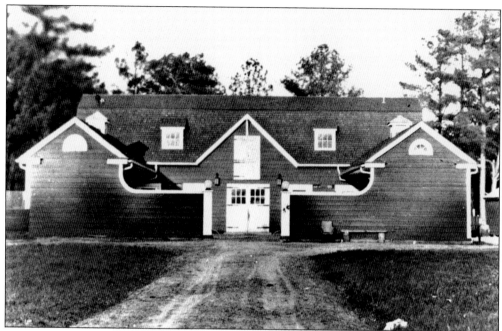

The riding stable stood adjacent to the passenger station and was one of the first buildings a visitor to Overhills would see. Since the 1920s, the stables have provided a focal point in this area of the estate. The c. 1920 photograph above shows the stables before renovation. Aside from structural appearance, this image contrasts with the photograph below, which offers a view of the approach to the stables around 1992. Over time, vegetation grew around the stables, including privet hedges and magnolia trees. Employees placed a high priority on maintaining the manicured, symmetrical approach, creating a pleasant environment for visitors to the stables. (Above, NC Archives; below, NC SHPO.)

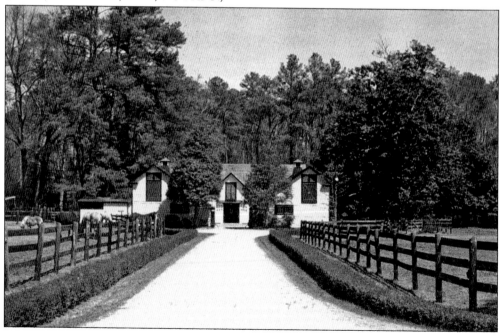

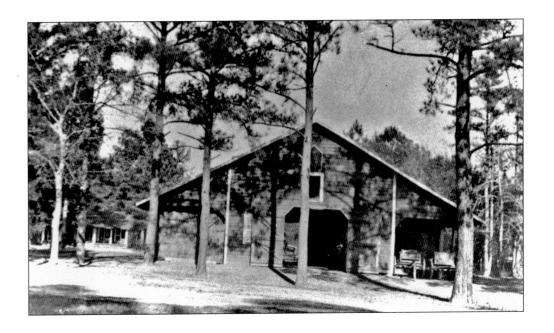

The polo barn allotted a dynamic space for activities. Likely it is the original farm barn, constructed in the late 1910s, used for housing horses and dairy cows. In the early 1920s, the barn was modified to house polo ponies of Averell Harriman, which were transported by train from New York. The above photograph shows the polo barn (foreground) and cottage (background) around 1920. Built around 1913, this house first served as the chauffeur's residence. Below, a c. 1930 group of hunters and bird dogs pause in front of the polo barn. The open bays were enclosed, and a larger hayloft door was added. (Above, NC Archives; below, Sandy Hemingway.)

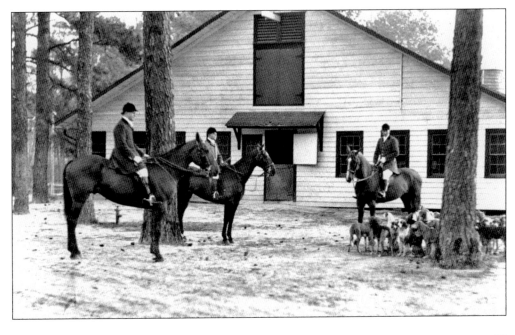

Looking toward the lake from the Jackson house, formerly the superintendent's house, the railroad track is visible in the center of this mid-1920s photograph. The lake can be seen through the longleaf pines in the background on the left. Following the railroad tracks to the right sat the Atlantic Coast Line freight station. (Brenda Mathews Hollenberg.)

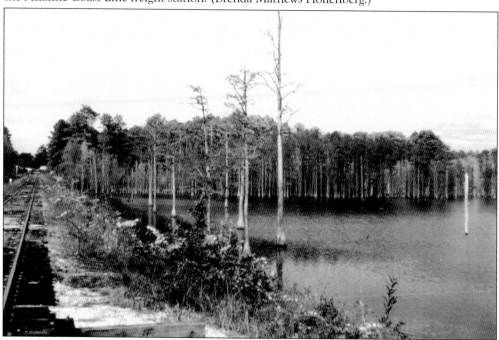

The Overhills Lake, a beautiful body of water, likely originated in the 19th century as a millpond on the McDiarmid turpentine plantation, fed by Muddy Creek. Over time, bald cypress trees ringed the lake to form a distinctive reddish curtain along the lake's margin in the fall. This c. 1960 photograph, taken from the south, shows the rail line that forms the lake's western boundary. (W. E. Bruce Jr.)

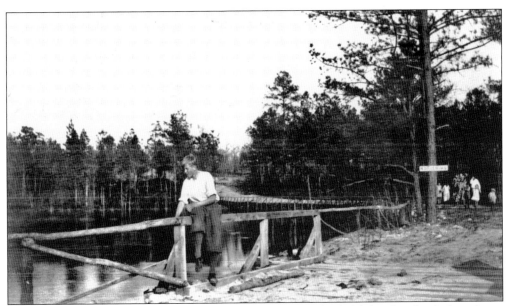

An earthen dam along the southern boundary of the lake held for decades before Avery Rockefeller commissioned a modern dam and locks in 1937 from Campbell Water Works. These photographs, above around 1925 and below in 1996, show similar vantages. Above, Bert Alabaster stands near the earthen dam with people in the background. Oddly enough, a sign on the tree reads, "No Fishing." The old public road running from Fayetteville through Overhills to Pinehurst is visible in the background. After the modern dam was constructed, the Rockefeller family created a relaxed setting on the shoreline, including Adirondack chairs, a dock, and a diving board. Long since privately owned, the road is obscured by trees in this photograph. (Above, Louise Alabaster; below, Fort Bragg.)

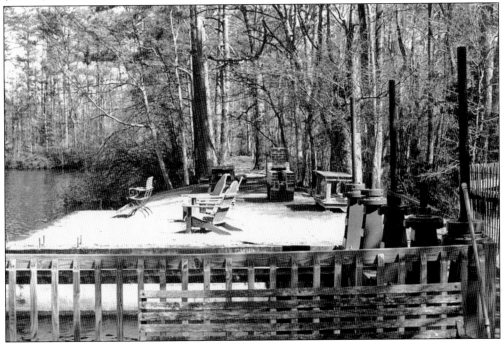

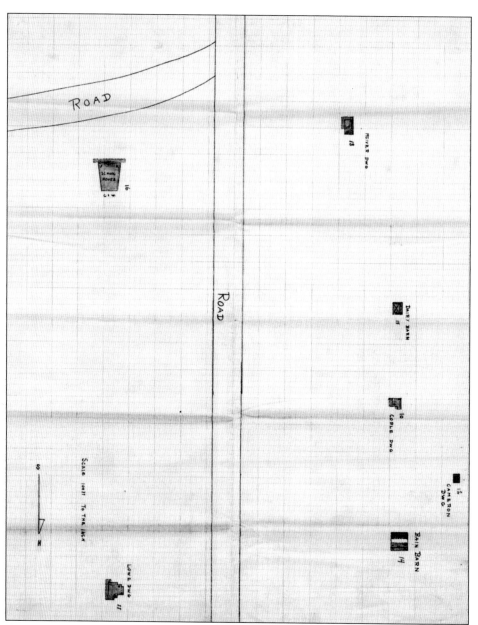

In the 1920s and 1930s, houses and supporting structures could be found on Overhills that were later abandoned and demolished. This 1927 insurance map shows buildings that are otherwise unrepresented in Overhills' records. Clockwise from top right, they are the McIver dwelling, dairy barn, Coble dwelling, Cameron dwelling, Bain barn, Lowe dwelling, and the schoolhouse. Employees and their families resided in this section of the estate between the railroad line and a creek. The Darden family, who later lived in the Cameron house, ran the dairy. Records note that the community house was sometimes used as a day school, but by 1929, Capt. Frank Miller, the Overhills superintendent, informed the insurance company that Overhills no longer owned the building. No other information is known about this structure. The Bain barn sat next to the Bain field, a popular location for bird hunting. Demolition dates of the buildings are unknown; none stood in the later decades of Overhills' operation. (Fort Bragg.)

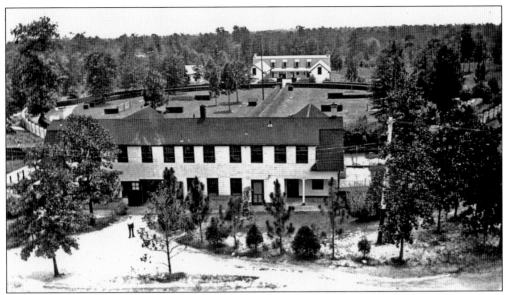

Located roughly one mile from the Hill, the hunt stables (background) and dog kennels (foreground) were for Percy Rockefeller's private use. They were constructed around 1921, about the time of this picture. This complex was known as the Circus. Foxhunting was popular in the 1920s and 1930s at Overhills, until Rockefeller's death in 1934. The stables were converted to a dairy in 1937. The dog kennels fell out of use and were demolished in the late 1950s. (W. E. Bruce Jr.)

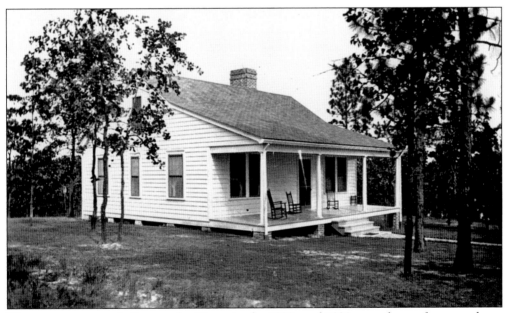

Three cottages were built near the Circus in the 1920s and 1930s, two for employees and one for the artist Percival Rosseau. All three houses sat on a hill overlooking the Circus. Percy and Isabel Rockefeller built this vernacular-style house in 1932 for newlyweds Walter Edward Sr. and Vernice Bruce. (W. E. Bruce Jr.)

Roughly four miles northeast of the Hill, the Lindley Nursery Company of Greensboro, North Carolina, established its Overhills branch in 1911 with the purchase of approximately 600 acres from the Kent-Jordan Company. Paul Cameron Lindley, grandson of the original proprietor, John Van Lindley, operated the Overhills nursery. Workers constructed a farm manager's house, a house for Lindley, at least three cottages for workers, and other agricultural structures. Crops shipped from Lindley Nursery via rail at Overhills included apples, grapes, Texas umbrellas, and Norway maple trees. Landscaping on the Hill and at nearby Fort Bragg came from the nursery. This branch continued until 1932, while Lindley Nursery operated in Greensboro until the 1960s. Above are Norway maples in the early 1910s. The caption read, "One of the best trees for street or yard." Below is the one-year apple crop. (Both, Greensboro Historical Museum, Inc.)

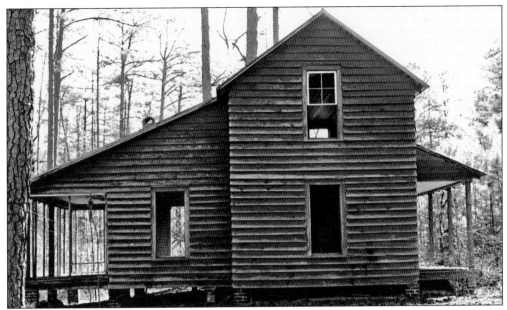

Constructed around 1911 to house employees of the Lindley Nursery, three similar vernacular dwellings stood near each other and across from the *c.* 1918 Paul Cameron Lindley house. When Percy and Isabel Rockefeller purchased the Lindley property in 1932, these three houses became residences for tenant farmers. This photograph was taken in 1992; little had been altered or modernized since its construction. (NC SHPO.)

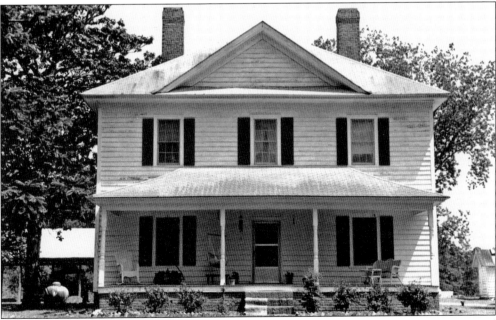

Atlas Simpson Davis moved to the area in 1911 to work as the Lindley Nursery manager and later for Overhills. Constructed about the same time, this two-story house was the home of the Davis family until he retired as farm manager of Overhills. The house, shown here in the 1990s, remained the largest employee residence at Overhills and the farm manager's home for decades. (Fort Bragg.)

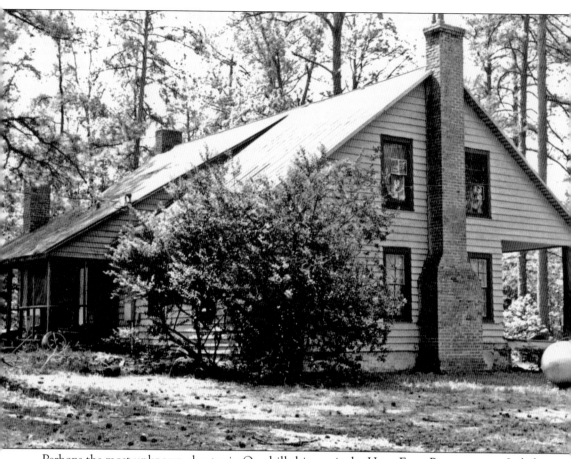

Perhaps the most unknown chapter in Overhills history is the Hope Farm Preventorium. Isabel Rockefeller purchased the Lindley Nursery property and buildings after it ceased operation in 1932. She used her own funds to start a preventorium—a place where local children at risk for tuberculosis could stay, free of charge, and receive rest, a healthy diet, medicine, and care from the staff nurses. Children followed a daily schedule of play and instruction. As part of Hope Farm, there was a goat dairy to provide the children with goat milk, a shower house, and the preventorium hospital itself. Rockefeller converted the prior nursery owner's house to offer dormitories for the boys and girls, a kitchen, living room, and nurses' quarters. The preventorium hospital only operated from 1934 to 1936, ending with the death of Rockefeller. Plans for a larger preventorium indicate that Rockefeller had hoped to help even more local children and make this a more lasting effort. (Fort Bragg.)

Two

HUNTING

The earliest hunts in the Sandhills were unconventional and a bit primitive compared to what would develop. North Carolina lawyer Aubrey Brooks described a *c.* 1908 hunt with James Jordan as "unorthodox," where the Greensboro party started a trip by "attaching a box car to a jerkwater passenger train and loading it with hounds and saddle horses." By the 1920s, hunting at Overhills had evolved into a more formal affair. A shooting syndicate was formed for bird hunting, and fox hunts were properly outfitted with facilities.

The Great Depression would diminish hunting activity at Overhills. The syndicate was dissolved in 1932. The death of Percy Rockefeller effectively ended foxhunting. Hunting soon faded as a popular activity. It is represented in this chapter by images and documents highlighting the landscape, individuals, and essential components of Overhills from the 1910s through the 1930s—bird dogs and hunt guides, kennels and stables, hounds and horses.

KENT-JORDAN COMPANY
OVERHILLS
NORTH CAROLINA

Game score for season 1919-20.

Party.	Season's bag.			
Stephen Birch.......	222 quail.	23 doves.		
John Cross.........	19 " .			
Col. B.K.Terry.....	11 " .	1 woodcock.		
C.J.Telford........	29 " .	1 turkey. 10 doves.		
Avery Rockefeller...	9 " .			
Alfred Swayne.......	11 " .			
S.Pryor Jr..........	1 " .	2 doves.		
Geo.McDougal................		2 turkey.		
Marshall McIver.............		1 turkey.		
Archie McFayden.......		1 deer (buck).		
John Munroe...................		1 deer (buck).		

Total score.	Quail.	Doves.	Woodcock.	Turkey.	Deer.	Foxes.
	302....	35...	1....	4....	2....	17.

While hunts at Overhills date to as early as the 1900s, few records survive prior to 1920. This record of game hunted in the Kent-Jordan era documents some of the hunting activity on the estate in the 1919–1920 winter season. The number of birds and foxes collected was comparable to the highest levels seen in the 1920s and 1930s. Among names listed here are club members, guests, and employees. Stephen Birch and S. F. Pryor were members of the club. Pryor was president of the Kent-Jordan Company at the time. The four last names are employees who were allowed to hunt on the property, some of whom also served as hunt guides in the 1920s. The remaining individuals, including 18-year-old Avery Rockefeller, were likely guests of the club members. In 1919, the Overhills Country Club included 12 members. (Fort Bragg.)

OVERHILLS SHOOTING SYNDICATE

Members as of February 15. 1927.

F.W.Allen	43 Exchange Place, New York City.
Wm F. Cutler	30 Church Street, "
John Speed Elliott	26 Broadway "
E.R.Harriman	26 " "
W.A.Harriman	26 " "
Chas. E. Mitchell	55 Wall Street, "
P.A.Rockefeller	25 Broadway "
Marshall Russell	71 " "
G.H.Walker	26 " "
Herbert H.White	c/o University Press, Cambridge,Mass.
Thomas H. White	c/o White Motor Co. Cleveland, Ohio. 842 E. 79th St.
Windsor T. White	c/o White Motor Co .Cleveland, Ohio. 842 E. 79th St.
Grayson M.-P. Myrphy	52 Broadway, New York City.

The Overhills Shooting Syndicate was established in 1923, after the Kent-Jordan era had ended. In addition to leasing hunting and fishing rights from the Overhills Land Company, the syndicate invested in the estate, building a dog man's house and a dog kennel. Membership was set at a maximum of 15 members, each of whom paid $500 a year in dues in return for accommodations at the Clubhouse, use of the golf course, and motor cars. Dogs could be boarded for $4 per day, and a daily limit of 20 birds was set. The syndicate lasted until the Depression took its toll on Overhills, and in 1932, it was terminated. Throughout its run, the syndicate included a core group of men with some yearly changes in membership. The document illustrated here lists shooting syndicate members in 1927. (Fort Bragg.)

GAME BOOK—OVERHILLS COUNTRY CLUB

Name	Date	Guide	Dogs	Game Bagged	Game Found	Section Hunted	Remarks
Harriman / Blagden / Harriman	Dec 5 1921	Jackson	Bronnie Dick	Quail – 13 { 6 Hens { 7 Cocks	7 Large Coveys	Bains	
" "	Dec 6	Jackson	Bronnie Nellie	Quail – 14 { 5 Hens { 9 Cocks	3 Coveys	Harris Place	
Harriman Capt. Fish Gordon S.R. Harriman Dale	Dec 6	Jackson + Neil	Little Company	Coons – 2	2 Coons	Thomas Place	
Blagden / Harriman	Dec 8	Jackson	Bronnie Dick	Quail – 12 { 3 Hens { 9 Cocks	4 Coveys (small)	Thomas Place	
Blagden / Harriman	Dec 9	Jackson	Bronnie Nellie	Quail – 12 { 6 Hens { 6 Cocks Doves – 2 ⑭	4 Large Coveys	Bains Place	
Harriman / Blagden / Harriman	Dec 10	Jackson Uncle Rhus	Sam George	Quail – 2 { 1 Hen { 1 Cock	3 Coveys quail 7 Turkey	McCoy Place	Shot only one quail—Turkeys too far out to...
Harriman / H. Blagden	Dec 10	Jackson	Bronnie Dick	Quail – 3 { 1 Hen { 2 Cocks	3 Large Coveys	County Beyond Nurseries	Saw Turkey Tracks
Harriman / R. Blagden / R. Harriman	Dec 12	Jackson	Bronnie Nellie	Quail – 19 { 7 Hens { 12 Cocks	5 Coveys	McDougal Anderson Creek McNeil	
H Blagden	Dec 15	Jackson	Bronnie Dick	Quail 8 { 5 Cocks { 3 Hens	3 Coveys	Townsend Place	
Bartlett	Dec 17	Jackson	Nellie George	Quail 2 { 1 Cock { 1 Hen	1 Covey	Thomas Place	Saw large Turkey
P. Vandell	Dec 19	Jackson	Bronnie Dick	Quail 7 { 4 Cocks { 3 Hens	5 Coveys	Bain	
P. Vandell / H. Blagden	Dec 20	Jackson	Bronnie Nellie	Quail 5 { 3 Cocks { 2 Hens	3 Coveys	Harris Place	
Monte Rockefeller / Rockefeller	Dec 21 21	Jackson	Bronnie Dick	Quail 3 { 2 Cocks { 1 Hen	8 Coveys	Bain	

A Game Book for Overhills reveals meticulous records of bird hunting from 1921 through 1932. For each season, the date; the number of guns; the names of the hunters, the hunt guide, and the bird dogs; the game bagged; and the game found were recorded. The peak season for bird hunting was 1929–1930, when 270 cocks and 187 hens were killed, and 323 coveys were found. In that season, 136 guns were taken to the field. Hunting parties typically ranged from one to three people. Also recorded were the areas hunted, which resulted in an impressive list of place names, recording local history. Old fields like the Bain field and homesteads like the Thomas, McCoy, Townsend, and Harris Place were regularly visited and recognized by the vacationing Northerners, or at least their guide. (Fort Bragg.)

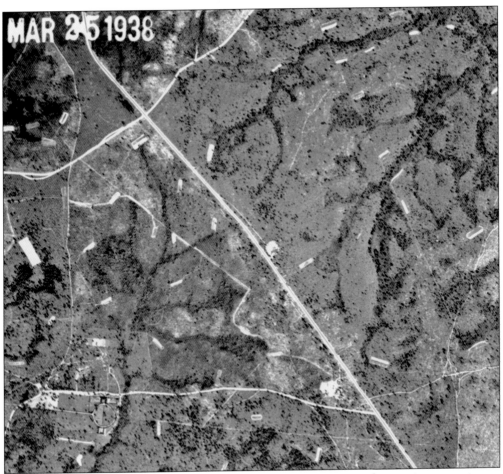

MAR 2 5 1938

For decades, the management of game birds was an important and extensive operation at Overhills. In this 1938 aerial photograph, taken as part of a series covering Harnett County, a number of "pea patches" dot the landscape. These small, cultivated fields, visible as white, linear, seemingly random areas in the photograph, provided food for the quail and other birds released and hunted on the property. The Overhills superintendent and staff ensured that these fields were maintained. In the 1920s, between 700 and 800 patches were planted with peas, sorghum, beggarsweed, millet, and lespidisa. Nearly 3,200 quail were brought onto Overhills between 1924 and 1928, with more than 1,500 killed. The patches, as well as agricultural fields, were critical for keeping birds on the property. While birds were imported, some quail were bred in captivity at Overhills as well. The dirt road that runs through this aerial photograph is the old Western Plank Road. The Circus is visible in the lower left. (NC Archives.)

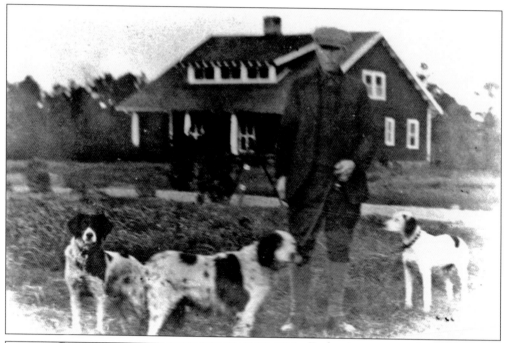

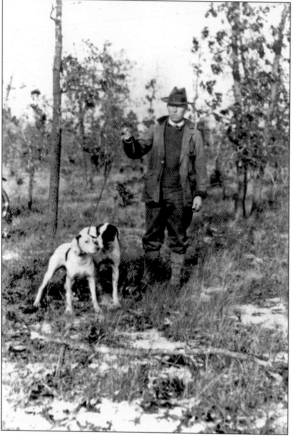

Each winter, two or three hunt guides carried most of the work at Overhills. Some of the more common guides were Luther Jackson, Charlie Hackett, Henry Lindsey, a Mr. Ferguson, and a Mr. Dorsett. In each of these c. 1920 photographs, an unidentified man poses with bird dogs. Hunt guides were typically kennel workers as well. The above photograph is near the golf course, with the Harriman Cottage in the background. At left is a c. 1920 scene in a patch of young scrub oak. Both of these men were likely guides who led club members and guests on regular bird hunts. (Both, NC Archives.)

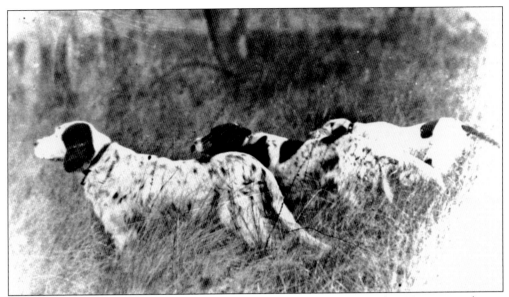

Bird dogs like these three English setters, in a photograph taken around 1925, were regulars at Overhills from the 1910s through the 1930s. It was the responsibility of the superintendent and kennel staff to monitor the dogs' health and hunting performance. A dog's typical weekly diet included raw meat two days, Spratt's biscuits two days, and a cooked meal of oatmeal, cornmeal, crackling, and fresh vegetables for three days. (NC Archives.)

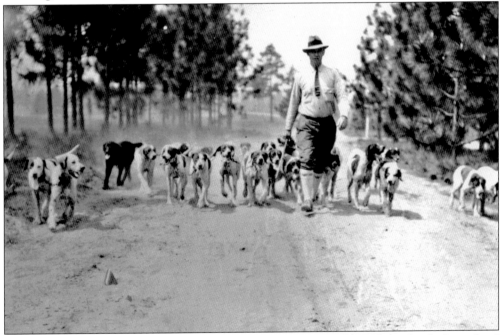

The Overhills Shooting Syndicate kept bird dogs at the estate and boarded individual members' dogs as well. In the 1921–1922 season, 12 dogs were in service, including Jack, Jigger, Lady, Mascot, Sport, Speed, Kitty, and Duke. In 1931, more than 40 dogs were kenneled. In this photograph, a well-dressed dog man with roughly two dozen bird dogs walks down a sand road at Overhills around the 1920s. (Louise Alabaster.)

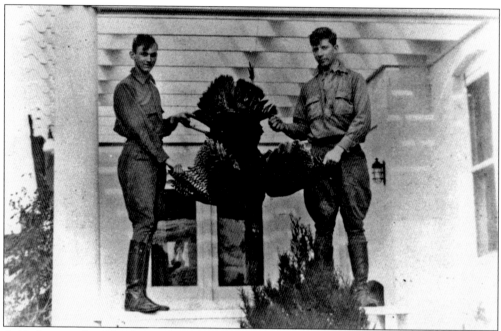

Aside from quail, wild turkeys were often sought. In his 1923 diary, Godfrey Rockefeller described a party of guests headed to Pinehurst, carrying shotgun and shells, hoping to shoot a turkey along the way. In this photograph, Griffith "Fritz" Mark (left) and Stillman Rockefeller display a gobbler on the Covert porch. The turkey population was of enough concern as early as 1919 to warrant a "turkey propagation committee." (NC Archives.)

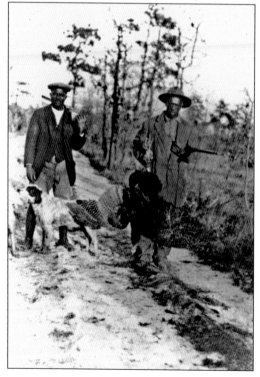

As guides or by themselves, employees at Overhills enjoyed the opportunity to hunt. Here two workers return from a c. 1920 hunt with dogs, bird, and shotguns in tow. Their dress suggests they may have accompanied a club guest. The number of wild turkeys at Overhills waned in the 1930s, enough to warrant importing some birds to mix with and improve the dwindling population. (NC Archives.)

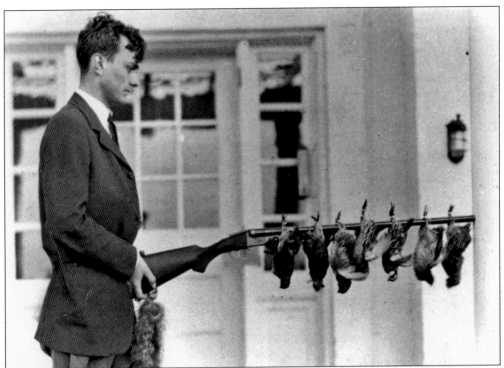

The quintessential Overhills sportsman, Griffith Mark poses outside the Covert, confidently displaying seven bobwhite quail strung from the barrel of a shotgun. Dressed in a tie and sport coat with a fox tail hanging from the rifle stock, Fritz epitomizes the lifestyle of the Overhills guest in the 1920s. These quail were likely served for dinner. (NC Archives.)

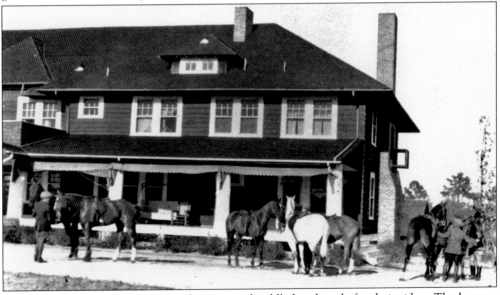

On a winter morning in the 1920s, horses stand saddled and ready for their riders. The hunters likely sit inside the Clubhouse, planning their adventure. From the Clubhouse porch to horseback, the party would ride to the Circus, where the chase would begin. Thereafter the hunt would cross a diverse landscape of open forest, fields, creeks, and swamps. (NC Archives.)

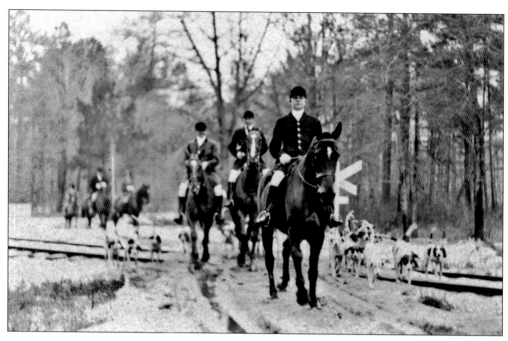

The sport of foxhunting in North America dates to the early 18th century, possibly earlier, with Colonial planters in Virginia and Maryland and Southern antebellum plantation owners enjoying the sport in their leisure time. By the early 20th century, foxhunting came to North Carolina with the establishment of numerous hunt clubs in the Piedmont and Coastal Plain. In the Sandhills, foxhunting developed at Overhills and nearby Southern Pines, where it is still practiced. The sport saw its heydays at Overhills in the 1920s, when winter scenes of hunters and packs became common. Above, a group of hunters with their pack of hounds is led over the railroad tracks at Overhills; a light snow covers the ground. Below, a foxhunter and a local huntsman pause on a sand road around 1925. (Both, David Alabaster.)

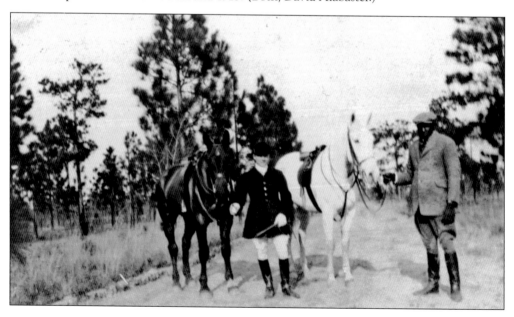

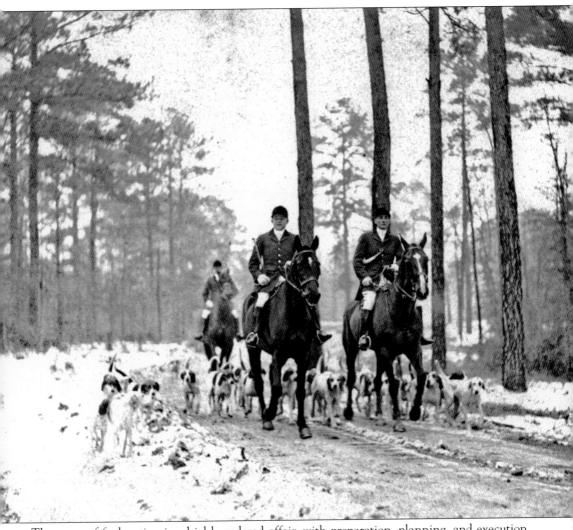

The sport of foxhunting is a highly ordered affair, with preparation, planning, and execution subject to high expectations of those who covet the chase. Two individuals were critical in the execution of a foxhunt. The master huntsman shouldered the great responsibility of ensuring that hounds, horses, and foxes were in order and that a hunt was properly run. In the photograph above, the man on the right likely serves this role. The horn he carries on his shoulder was used to announce the start of the chase. He would be assisted by a whipper-in, who was responsible for managing the hounds throughout the hunt. The master huntsman at Overhills was employed by Percy Rockefeller and lived in residential quarters above the hunt stables. In the 1930s, the huntsman was Rudolph Singleton, whom Rockefeller brought to Overhills from Kentucky. (David Alabaster.)

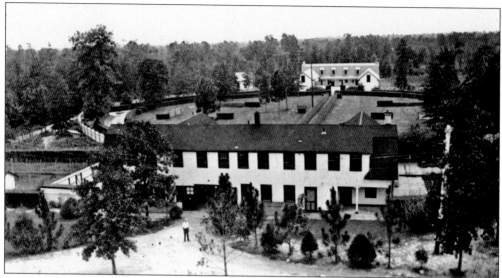

A club featuring foxhunting required adequate facilities for the care of hounds and horses. Percy Rockefeller built the Circus at Overhills just for this purpose. Shown above from the nearby hill, the kennel is in the foreground and the stable in the distance. This view was roughly the vantage from the artist Percival Rosseau's cottage and the Bruce Cottage. A remarkable architectural statement, the Circus included custom-designed stables and kennels opposite one another across an oval-shaped training area landscaped with hedges and outfitted with jumps. Pillars adorned with hound and fox statues marked the east and west gates. The Circus also served as the ceremonial launching point for the chase. Thomas described this hunt facility as a "very handsome hunting establishment, and perhaps the prettiest one to look at that I ever saw." (Above, W. E. Bruce Jr.; below, NC Archives.)

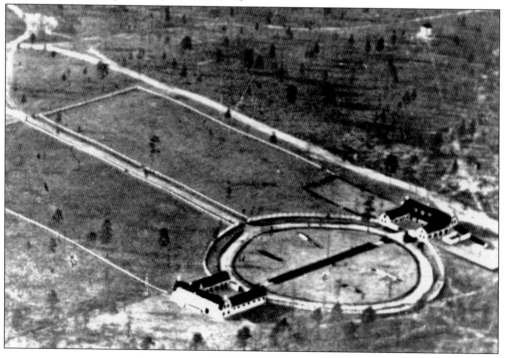

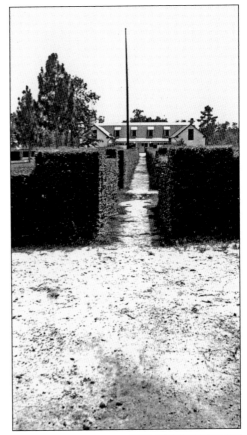

The kennels for hounds at Overhills (below c. 1925) were designed by J. B. Thomas. The original kennel plans included six lodging rooms for hounds, a cleaning room, a hospital and dipping room, and a hound cook's room. Hunt staff living quarters were included on the second floor. Fenced grass yards flanked either side of the kennel. When the hounds were not hunting, their daily care involved exercise, discipline, and a strict diet. Lodging rooms were cleaned regularly to avoid unsanitary conditions. The stables, shown at right c. 1925, mirrored the kennels in general plan. After the original wood-frame stables burned, a brick version was built in the late 1920s. Ten stalls bordered a courtyard, and living quarters and a dressing room were included upstairs. In the second version, cork bricks paved the paddock area. (At right, W. E. Bruce Jr.; below, NC Archives.)

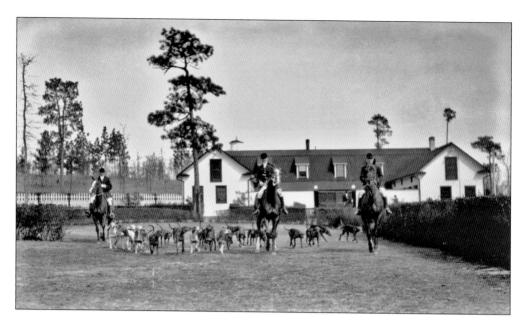

Surrounded by thousands of acres of pine forest, the Circus provided an elegant, structured landscape where the sophistication of hunter, horse, and hound was properly framed. Above, three unidentified riders gallop through the Circus with a pack of hounds, with the stable in the background, *c.* 1925. Below, a rare photograph of the original hunt stable shows three of J. B. Thomas's Thoroughbreds. Such horses were brought to Overhills by rail each winter and were returned to Greenwich or New York in the spring. The young knicker-clad kennel hands are unidentified but were likely brought with Thomas. The photographer for both of these shots was L. S. Sutcliffe. A professional with an office in Lexington, Kentucky, Sutcliffe photographed several foxhunting scenes at Overhills, publishing several shots in the *New York Times.* (Both, Ken Grayson.)

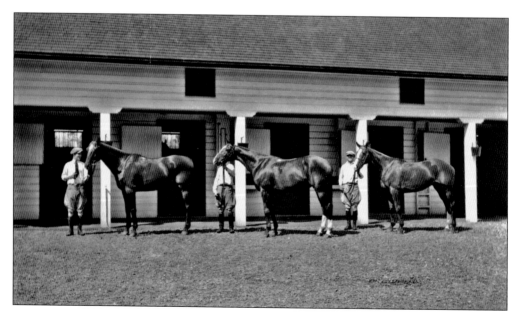

Overhills, N. C.

Receipt for Charges Collected from Consignee
41-08-388-33 1447 N

Office___ State___ OCT 23 1924 192___

(3001—11-41)

Mr. W B Bruce

To AMERICAN RAILWAY EXPRESS CO., Dr.
(Incorporated)

	Dollars	Cents	
For Transportation of 1 Crt 2 Dogs Declared Value $100.00			
1. Advance Charges			
From Millbrook State of N Y			
2. Value Charge			
Shipped by C W Carur	3. Express Charges "	9	52
Waybill Number 28932 Date of Shipment 10/22/24 Weight 18	4. Duties, Etc.		
	5. Amount of C. O. D.		
Received payment for the Company	6. C. O. D. Return Charge		
	Total	9	52

Hounds were shipped to Overhills in anticipation of the winter foxhunting season. J. B. Thomas likely provided the main pack each year, at least in the 1920s, as he rotated his pack between Overhills and Millbrook, New York, with the Overhills season running from November to January. The railroad shipping receipt above records a crate of two hounds being shipped to Overhills from New York in October 1924. The total declared value was $100. The list below records six hounds that Percy Rockefeller shipped by rail from Delaware in November 1933. These hounds were shipped to Rudolph Singleton. Mostly tick hounds, they appear to have been purchased by Overhills at a total cost of more than $400. (Both, Fort Bragg.)

LIST OF HOUNDS. RECEIVED BY EXPRESS NOVEMBER 26,1933.

#1	NIB	TRI-COLOR RED HEAD	$62.50
#2	JOY	BLUE TICK (BITCH)	50.00
#3	BONY	BLACK & WHITE	50.00
#4	RINGS	BLUE TICK	50.00
#5	ANDY	TRI-COLOR	50.00
#6	AMOS	BLACK & WHITE	50.00
#7	PEANUTS	BLACK & WHITE TICK	50.00
#8	NIBLER	BLUE TICK	50.00
		COST OF CRATE	4.00
		EXPRESS FROM DELAWARE	7.77
			$424.27

OVERHILLS **H U N T**

OVERHILLS P. O.
NORTH CAROLINA

December 31st, 1927.

Labors time on Hunt Country and Kennel Dept.

Andrew Manroe	23½	days @	$ 2.00	$ 47.00	✓
Willie King	25	" @	2.00	50.00	✓
Nathin Johnson	25	" @	2.00	50.00	✓
John Dobbin	28½	" @	2.00	57.00	✓
Ed.McCarther	6	" @	2.00	12.00	✓
				216.00	✓

Carpenter Labor building on to

Garage at Studio.

J.W.Lofton	5 days @ $ 4.00		20.00 ✓		
Walter Elloit	3 " @ 3.00		9.00 ✓	29.00	
	Total,			$ 245.00	✓

While at Overhills, hounds and horses enjoyed the benefit of a full-time staff. The Overhills Hunt and Kennel Department regularly employed five to eight men in the 1920s. This 1927 payroll statement records the monthly labor and pay for seven. The labor of the five men at the top likely included work with hounds and/or horses. Of note in this list of names are Willie King and John Dobbin. King would go on to serve as the riding stable manager well into the 1960s. Dobbin would occasionally serve as a bird-hunting guide in addition to working in the Circus. Listed at the bottom is the labor of two men for construction at Percival Rosseau's cottage, which was located near the Circus. The inclusion of work on Rosseau's cottage in this account reflects Percy Rockefeller's patronage for the artist and personal investment in the hunt and kennel club. (Fort Bragg.)

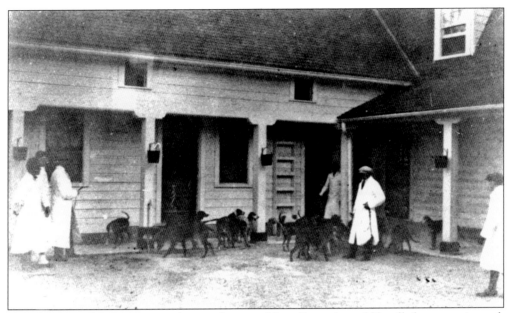

In foxhunting, the importance of caring for a good lot of hounds could hardly be overestimated. Careful attention to meal preparation, bathing, exercise, discipline, and personality were all part of the care of a pack. In this 1920s photograph, six men in white coats are shown working at the kennel. (NC Archives.)

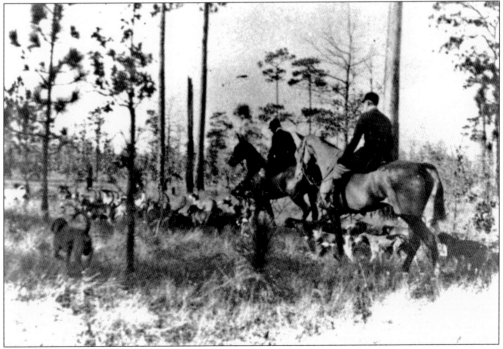

The open canopy and sparse mid-story of the Overhills landscape offered a perfect landscape for the expansive sport of foxhunting. Several factors contributed to the open forest, including late-19th-century timber cutting and frequent wildfires. The thick wiregrass groundcover and longleaf pines seen in this 1920s photograph are both fire-adapted species. (NC Archives.)

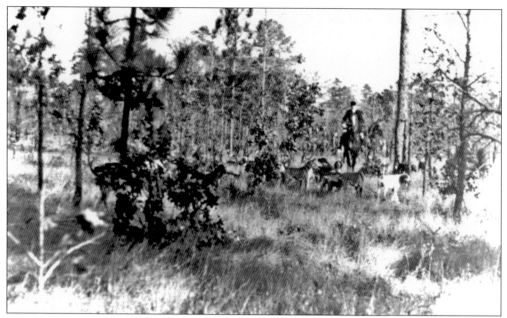

This *c.* 1920s photograph of a mounted rider and pack of hounds illustrates the gentle slope and typical forest cover of Overhills. Young longleaf pines and some scrub oak have taken hold in the cut-over and well-burned forest. The single large pine behind the hunter's left is a relic of the naval stores industry, with a long vertical scar of the old cat-face where gum was extracted. (NC Archives.)

With its rolling hills, open forest, and absence of fencing or wire, Overhills' land was well suited for the chase. One distinctive terrain feature presented a challenge for the hunter and an advantage for the hunted. The hills were thoroughly dissected by small streams that were often choked with vegetation, contrasting sharply with the surrounding ridges. These wetlands frustrated the foxhunter and served as a covert for the fox. (Sandy Hemingway.)

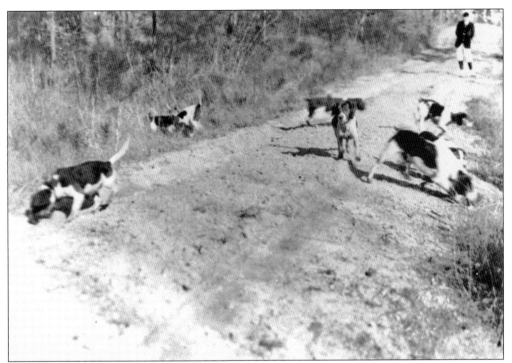

This photograph captures a pack of hounds that has checked, losing the scent of a fox along a sand road at Overhills in the 1920s. The hunter, dismounted, waits patiently while the hounds cast about to recover the trail. J. B. Thomas recalled a similar scene from an Overhills hunt in which a passing car interrupted the chase. (NC Archives.)

The quarry for foxhunters at Overhills included foxes native to the Sandhills and foxes shipped in by rail. This 1926 receipt is for foxes shipped from a fox farm in New York. The majority of foxes brought into Overhills during the 1920s came from New York, though some shipments came from Virginia, Alabama, Connecticut, Michigan, and Louisiana. (Fort Bragg.)

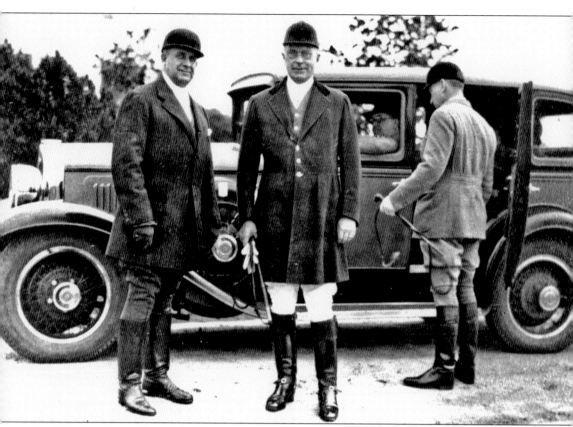

Foxhunting could often be a social event. Historic newspaper articles refer to "well-attended" hunts or meets. At Overhills, foxhunts were likely restricted to small groups with a limited audience in the seemingly endless forest. Nonetheless, Percy Rockefeller used the opportunity to run the hounds to entertain guests and friends. One particular short-lived tradition of note began in 1928, when Rockefeller and Frederic Allen invited 14 living members of the 1900 class of Yale for a winter visit to the estate. This tradition lasted for three years. Some of the individuals included in these groups were William Sloan Coffin (president, Metropolitan Museum of Art), Corliss E. Sullivan (chairman, Central National Bank), and John W. Cross (Cross and Cross Architects). In the photograph above, Percy Rockefeller (center) and two unidentified friends emerge from a limousine, dressed and ready for the chase. (NC Archives.)

Created in 1934, this card signifies the end of an era at Overhills. For the purpose of a sale, it lists the hounds and puppies that remained in the hunt department kennels after Percy Rockefeller's death. The penciled edits reflect the current status of the dogs and their pedigree: "m" stands for Maryland and "w" for Walker. Most of these dogs were sold to a North Carolina farmer for $5 each. This was the last year of foxhunting at Overhills, a season in which some 14 foxes were killed. With the passing of Percy Rockefeller in 1934, foxhunting would no longer have a proponent at the estate. (Both, Fort Bragg.)

OVERHILLS HUNT

OVERHILLS
HARNETT COUNTY
N. C.

Nineteen Hundred and Thirty-four

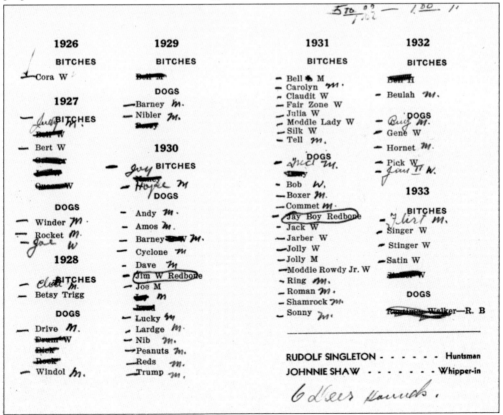

1926	1929	1931	1932
BITCHES	BITCHES	BITCHES	BITCHES
Cora W	~~Bell~~ M	– Bell ♣ M	~~Bell~~ M
1927	DOGS	– Carolyn *m·*	– Beulah *m·*
BITCHES	–Barney *m·*	– Claudit W	
	– Nibler *m·*	– Fair Zone W	DOGS
Bert W	~~Dusty~~	– Julia W	– Quig *m·*
		– Moddle Lady W	– Gene W
~~Queen~~ W	**1930**	– Silk W	– Hornet *m·*
	BITCHES	– Tell *m·*	– Pick W
	Joy		– Jam II W.
DOGS	*Hoyle* m	DOGS	
	DOGS	*Juel m.*	**1933**
Winder *m·*	– Andy *m·*	~~Terry~~	BITCHES
Rocket *m·*	– Amos *m·*	– Bob W.	– Flirt *m·*
Joe W	– Barney ~~W~~ *m·*	– Boxer *m·*	– Singer W
1928	– Cyclone *m*	– Commet *m·*	– Stinger W
BITCHES	– Dave *m*	Jay Boy Redbone	– Satin W
Ellen m.	Jim W Redbone	– Jack W	
– Betsy Trigg	– Joe M	– Jarber W	DOGS
	~~~~ *m*	– Jolly W	~~Tophler~~ Walker—R. B
DOGS	~~Loud~~	– Jolly M	
– Drive *m.*	– Lucky *m*	–Moddle Rowdy Jr. W	
~~Drum~~ W	– Lardge *m·*	– Ring *m·*	
~~Dick~~	– Nib *m·*	– Roman *m·*	
~~Dock~~	–Peanuts *m·*	– Shamrock *m·*	
– Windol *m·*	–Reds *m·*	– Sonny *m·*	
	–Trump *m·*		

RUDOLF SINGLETON · · · · · · Huntsman
JOHNNIE SHAW · · · · · · · Whipper-in

*6 deer hounds.*

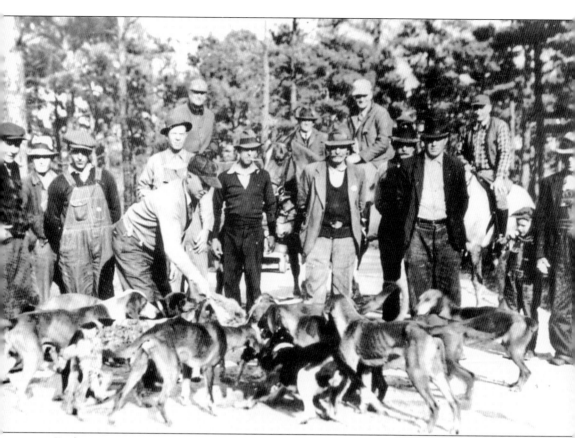

Foxhunting was not necessarily restricted to the privileged class at Overhills. This photograph, labeled "Night Hunters," shows a group of local men after a night hunt. These hunts were common among farmers in some areas of the South. With much less ceremony and formality than those conducted by Rockefeller and Thomas, the night hunts were conducted on foot in the moonlight. Hounds owned by the individual hunters were released together and their distinctive cries were followed by their owners while the hounds chased their quarry. The hunters would typically wait by a fire on a ridge across which they expected the chase to run. (Christopher Elliman.)

# *Three*

# RECREATION

With roots as a relatively understated hunt club, Overhills would quickly become a refined, albeit pastoral, country club with diverse recreational offerings. The estate featured several recreational amenities. The golf course at Overhills was a centerpiece and one of the earliest investments. Horseback riding at Overhills was a natural complement to the bucolic setting, well suited to the expansive acreage. An old lake was stocked with fish and was used for boating and swimming. The 1920s saw the short-lived stint of polo at Overhills and the introduction of tennis, which waxed and waned over the years.

This chapter presents images related to a range of activities, particularly in the club years of Overhills. Emphasis is placed on golf and the course that existed for so long in relative obscurity. Horseback riding is the second focus, as it became the favorite activity for multiple generations of the Rockefeller family.

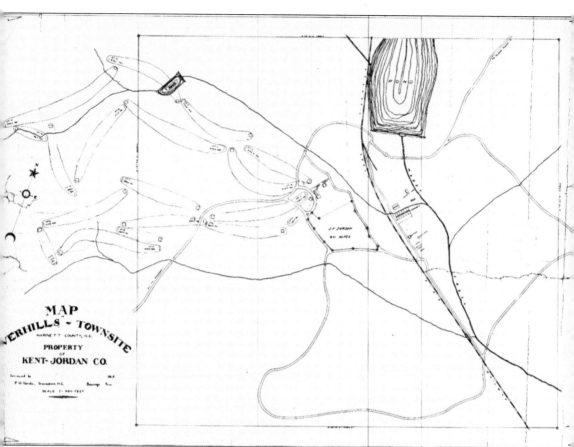

The Overhills golf course was completed, at least in its initial form, by 1913. The map above, surveyed by P. W. Hardie of Greensboro in the same year, shows the original course layout, along with other early estate features, including the Clubhouse, servants' quarters, road network, railroad, passenger station, tennis court, stables, kennels, and Overhills Lake. The map title, "Overhills Townsite," reveals the speculative ventures of planned communities considered by the Kent-Jordan Company early in Overhills' history. While the early identity of Overhills was based largely on hunting, golf was clearly a focus of investment. The course was likely of the highest caliber produced by Donald Ross. In 1919, the Overhills superintendent remarked that a professional acclaimed the course as better than any at Pinehurst. However, the Overhills course would always be private with limited exposure, never garnering the attention or frequency of high-profile country clubs. (NC Archives.)

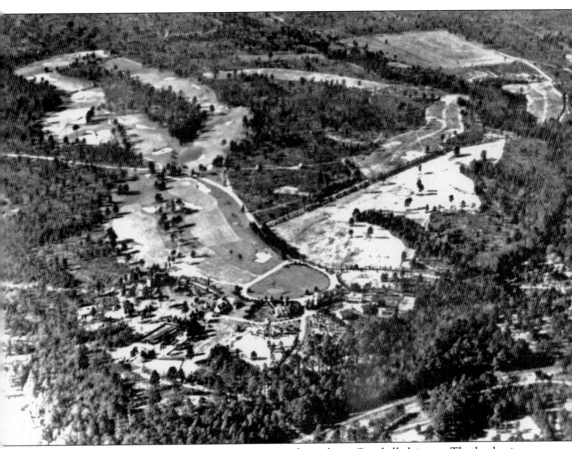

The front nine of the golf course was kept in use throughout Overhills history. The back nine holes, however, were closed for roughly three decades. Around the time of the Great Depression, the back nine was abandoned, reflecting the economic challenges of the times and decreased activity at Overhills. Holes 10 through 18 would sit idle and become overgrown until the late 1950s, when renewed golfing interests inspired an attempt to reestablish an 18-hole course. While the general layout was followed, the back nine was not restored to the original Donald Ross design, and some significant changes were made. In this late 1930s photograph, the front nine is visible on the left, while the abandoned back nine is on the right. The polo field is visible in the upper right, located along the side of the 15th fairway. (NC Archives.)

Two scorecards from different decades can be used to illustrate the changes in the Overhills Golf Course over the years. The card at left portrays the original course layout, as designed by Donald Ross. At 6,544 yards, the course was comparable to some of Ross's longer designs in nearby Pinehurst and Southern Pines. This card likely dates to the late 1910s. The card below depicts the back nine after its renovation in the late 1950s. The original No. 14 was removed. The original holes Nos. 12 and 13 became holes Nos. 13 and 14, respectively. The modern hole No. 12 was carved from the original hole No. 11. Hole No. 15, which had a portion of its fairway converted to a polo field, was reduced in length when it was rebuilt. (Both, Fort Bragg.)

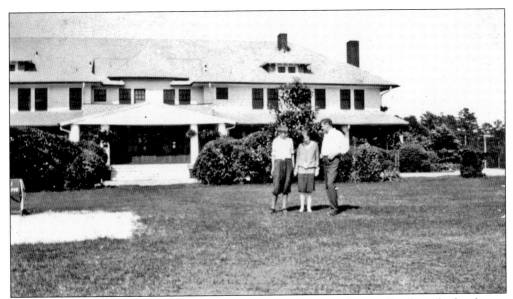

For Donald Ross, the open terrain available to his creative mind seemed to have had only one stipulation: accessibility to the Clubhouse. For guests, a round of golf at Overhills began steps away from the front door. In this *c.* 1925 photograph, (from left to right) Bert, Doreen, and Albert Alabaster stand near the first tee, the rectangular sand area on the left. (Louise Alabaster.)

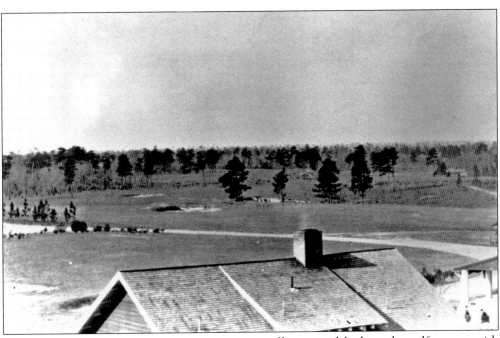

This *c.* 1920 bird's-eye view from a water tower offers a good look at the golf course, with Harriman Cottage in the foreground and the Clubhouse porch in the lower right. The edge of a bunker at the ninth green is visible in the lower left. Toward the background, in the middle of the photograph, a set of bunkers guards the 18th green. (NC Archives.)

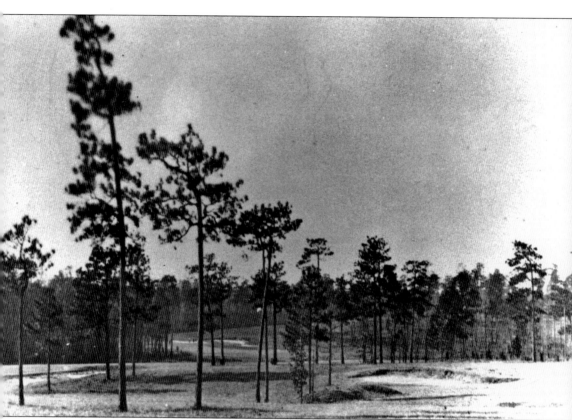

A view from the third fairway includes a bunker near the second green (right) and the fairway and distant green on the fourth hole (left). The original design of the second hole included four bunkers—two flanking the green, one roughly 110 yards in front of the green, and a large fairway bunker at about 150 yards from the tee. The fourth hole was one of the longest at more than 500 yards. Two fairway bunkers, one large pit at 150 yards and a small one at 350 yards, challenged the preferred angle for the dogleg left. A natural stream, the dip in the land visible above, crossed the fairway at about 380 yards, and another large bunker (visible in the distance) protected the right side of the green. After playing the fourth hole, the par-three fifth hole led up the hill, ascending to the right in the distance. (NC Archives.)

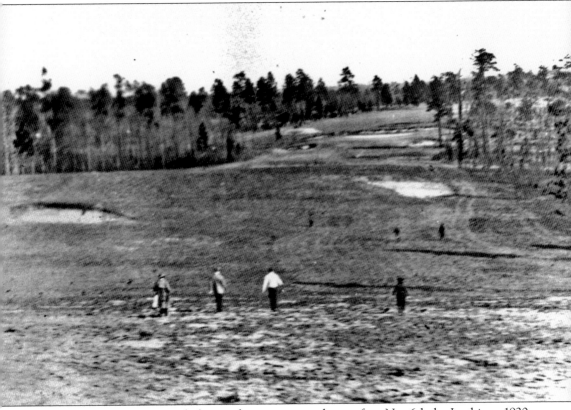

One of the most impressive holes on the course was the par-four No. 6 hole. In this *c.* 1920 photograph, a group of golfers walks the fairway after a tee shot. Donald Ross's design of this hole included five hazards. The two fairway bunkers, or "pits," visible in the foreground were encountered at roughly 180 yards (left) and 220 yards (right) from the tee. A wiregrass mound on the left side of the fairway about 350 yards from the tee preceded two small bunkers flanking the green. The original length of this hole was 417.9 yards, with the typical tee shot plotted at 250 yards. With an elevated tee and a low ridge crossing the fairway, this single hole challenged the golfer with multiple elevation changes. The rolling terrain visible here is typical of the Sandhills. The only earth moved to create this hole came from the tee boxes, bunkers, and greens. This photograph illustrates the natural topography, along with those course features carved from the sandy soil. (NC Archives.)

Situated atop the highest landform on the course, the sixth tee offered a fantastic panoramic view of the surrounding landscape. In this photograph, a golfer tees off at the No. 6 hole in the 1920s. Visible through the trees to the right is the fairway of the second hole. (Brenda Mathews Hollenberg.)

The 360 yard, par-four eighth hole approached the Hill. From left to right, the Clubhouse, Harriman Cottage, water tower, and Covert are visible in the distance. The bunker in the foreground is approximately 140 yards from the tee. On the far left is the first fairway, leading away from the Clubhouse. The open view between these fairways would eventually be obscured by mature pines. (NC Archives.)

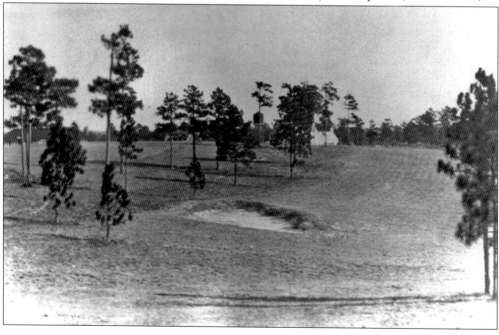

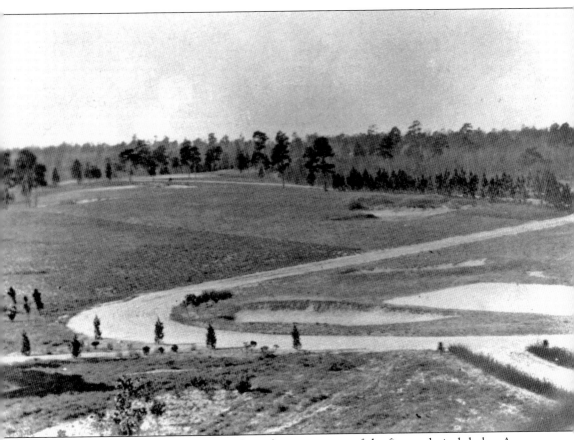

This *c.* 1920 photograph offers a view from the water tower of the first and ninth holes. A par three at 150 yards, the ninth hole returned players to the Clubhouse and cottage area. The rectangular, sand, ninth green visible here was altered by the late 1930s. The green was reduced in size, re-shaped, and possibly relocated. In addition, the two Donald Ross signature bunkers were removed. Hole No. 1, which is visible in the distance, was a par five at 509 yards. The large bunker on the right side of the first fairway was also removed in the 1930s. No other major changes were made to the front nine holes. The two landscaped pathways in the foreground led visitors from the circular drive to Harriman Cottage (to the right) and Covert Cottage (to the left). (NC Archives.)

A golfer follows the flight of his tee shot at Overhills around 1920. As typical of the early 20th century, the golfers in these photographs likely carried no more than six clubs in their bags. Instead of today's standard numbers, the hickory-shaft clubs in use in the 1920s may have been called by traditional names, such as brassie, spoon, cleek, mashie, and niblick. (NC Archives.)

Teeing off at Overhills in the 1920s, as illustrated in these two photographs, differed from modern golf in several ways. The dress code could be a bit formal by today's standards. Like the putting greens, the tee boxes at Overhills were originally sand. The choice club would be a driver made with a hickory shaft and a solid wood head made of persimmon. (W. E. Bruce Jr.)

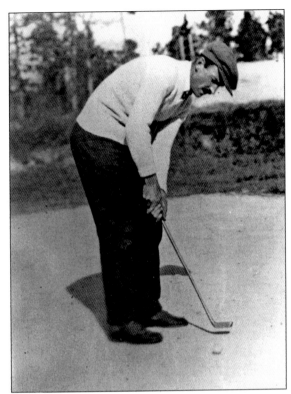

Like many courses in the early 20th century, Overhills was built with sand greens. In most cases, these were a sand-and-clay mixture. After putting out on a sand green, the player or caddie smoothed the sand surface with a special rake or burlap bag. Sand greens were maintained at Overhills until the 1950s. Since their original construction in 1913, the greens were altered at least once by the early 1930s, being reduced in size. These photographs show two men, both unidentified, putting on sand greens at Overhills. While the hole at right is unidentified, the hole in the photograph below is clearly No. 3, a short par three. The marker visible in this photograph would be replaced by red cloth flags in the late 1920s. (At right, NC Archives; below, W. E. Bruce Jr.)

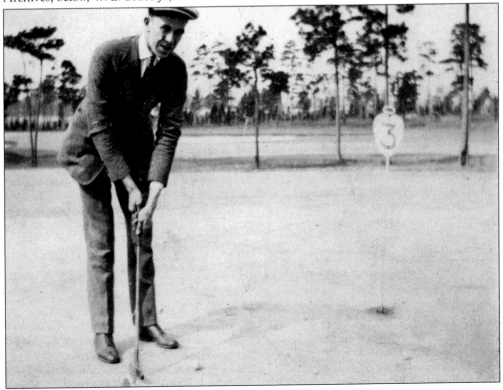

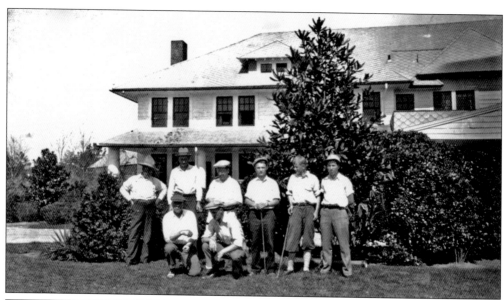

## HANDICAPS

L. W. JACKSON	... ...	0
Robert Jackson	... ...	-8
HOWARD JACKSON	... ...	+4
HOMER JACKSON	... ...	-6
Mack LOWE	... ...	0
BERTIE ALABASTER	... ...	+4
TOM SORENSEN	... ...	+4
W. WHITFORD	...	-16
GEO. WHITFORD	...	-16
W. S. WEST	...	-16
P. FERGUSON-DAVIE		-30
GEO. THOMAS	...	-30
W. DOUGLAS	..	-16
AMOS SCHERMERHORN		-16
B. BRUCE	... ..	0
F. N. MILLER	...	0

Overhills employees likely played as much, if not more, golf than visitors to the estate. In the above photograph, a group of employees prepared for golf pose in front of the Clubhouse around 1925. Two are identified: Bert Alabaster is second from right, with the Jackson brothers on either side. The son of Percy Rockefeller's valet, young Bert was a scratch golfer. (Louise Alabaster.)

The only golf tournaments known from Overhills were held by staff in the 1920s. Listed are the players in one such tournament in 1929, including laborers and the superintendent, Capt. Frank N. "Dusty" Miller. Handicaps varied widely. By this time, competition likely included only the front nine since the back nine was closed. (Fort Bragg.)

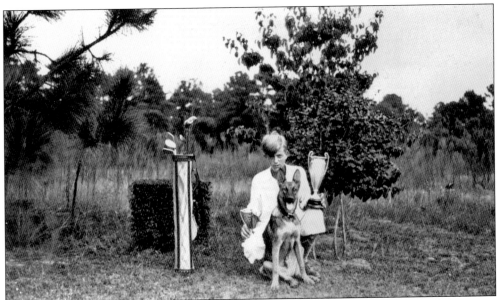

Bert Alabaster won the annual staff golf tournaments of 1928 and 1929, when he was just 15 and 16 years old. In this *c.* 1929 photograph, he proudly displays his Love Cup trophies along with his dog and his clubs. Aside from Overhills tournaments, he played matches at Fort Bragg. (Louise Alabaster.)

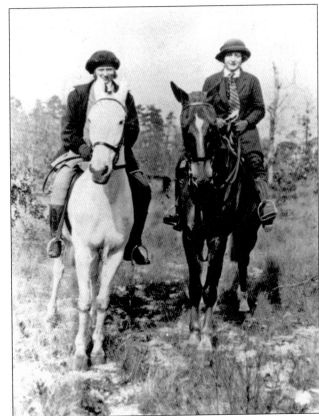

Beyond golf, horseback riding became one of the most enduring recreational activities at Overhills. The Rockefeller family, in particular, would develop a passion for riding. In this *c.* 1920 photograph, cousins Faith (left) and Almira Rockefeller are ready to explore the property on horseback. (NC Archives.)

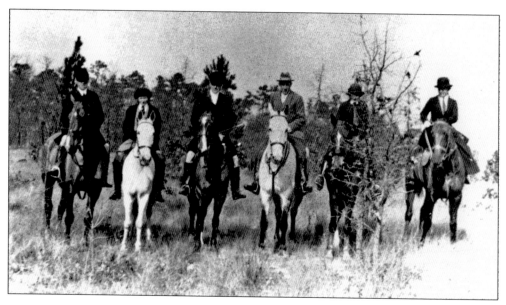

The landscape of sandy soil, longleaf pines, and old logging roads originally adopted for hunting land provided ideal horseback riding rails throughout Overhills. Whether a huntsman, horseman, or a casual rider, all visitors could easily appreciate the terrain. A warm agreeable climate complemented the scenery and open space, allowing visitors to take daily rides. In the *c.* 1920 photograph above, unidentified, Faith Rockefeller, Percy Rockefeller, Roy Jackson, Almira Rockefeller, and Isabel Rockefeller pose on horseback, likely during a mild winter's visit. Isabel appears to be riding sidesaddle. Below, Griffith Mark (left) and Stillman Rockefeller pose on their horses while the third horseman, unidentified, shoots the photograph. (Both, NC Archives.)

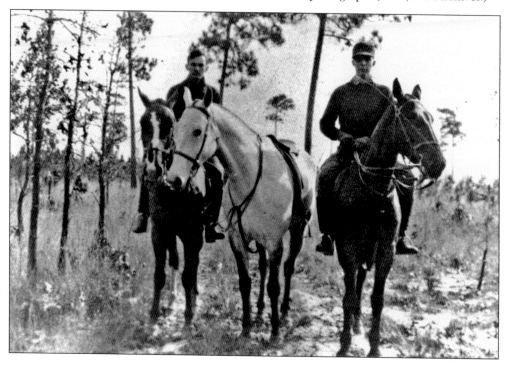

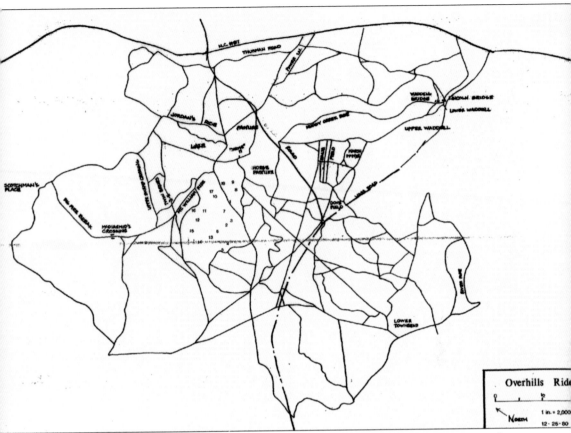

Overhills Ride

Horseback riding trails traversed nearly the entire estate, passing old home sites, tenant farms, bird feed patches, and creeks. Stable hands monitored, maintained, and created the horse trails, many of which were originally cut in the 1920s and 1930s as firebreaks. The majority of riders had guides to lead them on the horse trails. A few more experienced riders went out alone. Guides could choose from a wide variety of routes, offering varied scenic destinations and durations. This map of rides, drawn about 1980, shows many of the historic and modern rides on the west side of Route 87 (located at the top of the map). The numbers 1 through 18 represent the golf course and the Hill area. The names representing the rides are typically associated with historic place names, fields, or the person who favored the ride, such as Jordan. (Fort Bragg.)

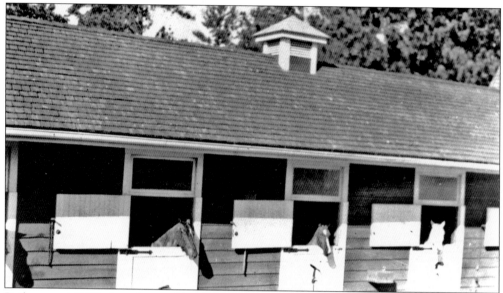

Built around 1920, the riding stables were remodeled around 1924. These photographs (above c. 1920 and below c. 1990) illustrate some of the changes. Additions involved raising the roof for a hayloft, creating more stalls, and extending the eaves of the roof on both lengths of the U-shaped building to provide cover overhead. The transoms were removed. Nameplates were placed above each horse's stall. The first floor of the renovated stables incorporated a tack room, groom's quarters, a service room, and a dressing room for the riders. Each stall was outfitted with a wrought-iron hay rack and corner manger from the 1924 catalog of the J. W. Fiske Iron Works Company of New York. (Above, NC Archives; below, Sandy Hemingway.)

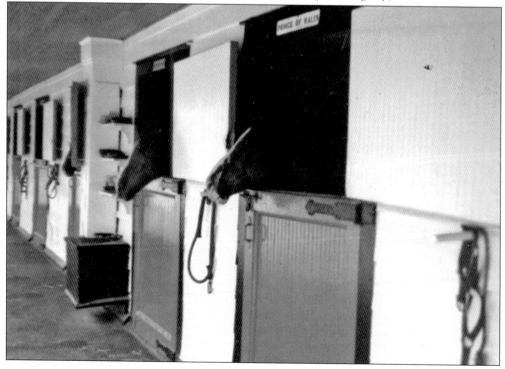

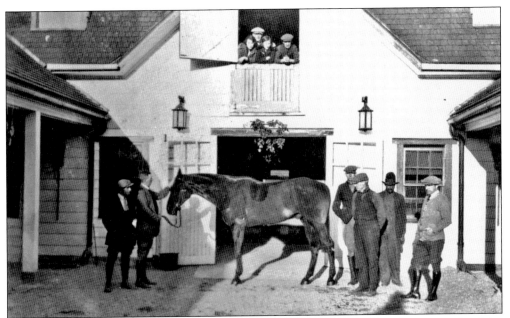

Employees, club members, and visitors often gathered at the riding stables, the center of activity for decades, in the winter months. Whether looking forward to riding or simply viewing the horses, children and adults were welcomed at the stables. In this 1925 photograph, stable hands and prospective riders inspect a horse. Above the stable doors, children peek out of Dutch doors from the stable manager's residence. (Louise Alabaster.)

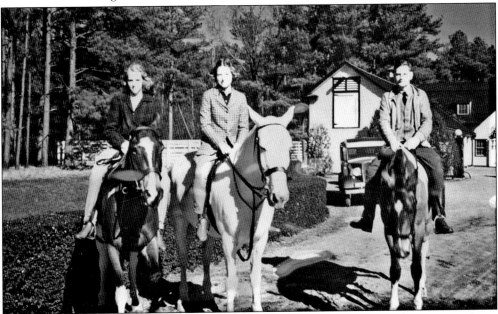

A short walk or drive from the Hill led to the Overhills riding stables, where horses were always prepared for their riders. Employees exercised, groomed, and saddled the horses for visitors. In this photograph, (from left to right) Lee Coombe, her cousin Isabel Lincoln, and Isabel's father, Frederic Lincoln Jr., pause for a photograph on their horses in front of the riding stables c. 1940. (Isabel Elmer.)

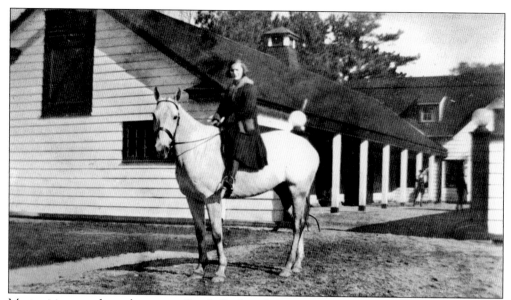

Most visitors and employees at Overhills found favorites among the horses. A few of the horses' names recalled by the Rockefellers included Gallop Off, Good Guy, Prince of Wales, Snowflake, Bongo, and Long Distance. In this *c.* 1925 image, Doreen Alabaster is about to ride, possibly taking this horse for exercise. She appears in other photographs with this same horse. (Louise Alabaster.)

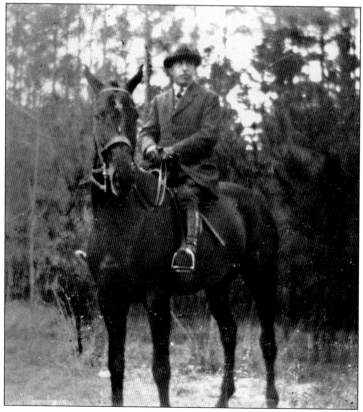

A wide range of horses ensured that anyone, from the seasoned rider to the beginner, would find a compatible horse for the outing. Visitors were not required to bring their own tack and riding equipment. Employees cared for the communal tack, which was stored in the stable tack room. In this *c.* 1930 photograph, the unidentified rider sits comfortably on horseback after being outfitted at the stables. (W. E. Bruce Jr.)

Many of the Rockefeller generations rode one of several ponies named Patches at some point on their Overhills visits. Guest book entries recall experiences with odes of "I love Patches." This 1958 letter from Avery Rockefeller to W. B. Bruce discusses the possibility of obtaining one or two more ponies from "out west." The markings and colorings on the new ponies were requested to resemble the old Patches, for which Rockefeller enclosed the photograph, below, with his letter. In this *c.* 1950 photograph, employee Willie King stands beside one Patches with an unidentified young boy sitting atop the pony. (Both, Fort Bragg.)

MEMORANDUM

To:

From:                                    Date: Oct. 3, 1958.

Dear Une, -

Enclosed are some pictures of the old Patches. They give you a pretty good idea of his size and shape. If the dealer out west could find one or two like him we could certainly use them.

Jenny is still in the hospital I doubt if she can travel for at least 3 or 4 weeks so there is no hurry about opening Sycamore on her account.

What's happened to Dot?

Hastily, A. R.

SCHRODER ROCKEFELLER & CO., INCORPORATED • 61 BROADWAY • NEW YORK 6 N.Y.

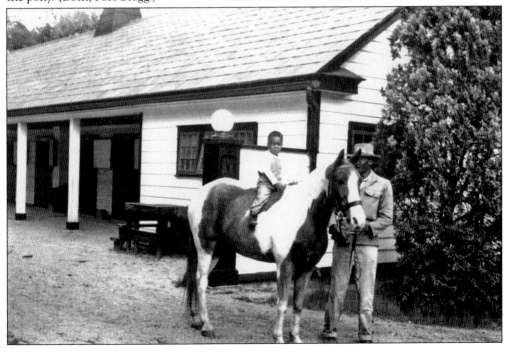

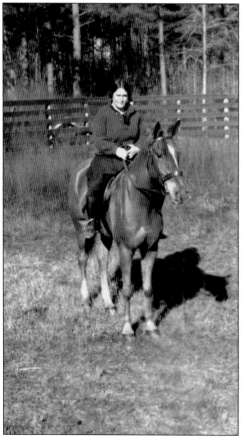

In the 1930s, Rockefeller family members with their own stables in Connecticut would send horses down to Overhills to ride. Many other horses would be boarded at Overhills year-round throughout the estate's history. During the summer months, horses passed the days in pastures and were regularly exercised and cared for by stable hands. On either side of the riding stables, pastures provided the horses with room to run outside the confines of the stall walls. In the above c. 1950 photograph, Willie King and Patches stand in front of the pasture between the passenger station (visible in the distance) and the stables. On the opposite side of the stable drive, there was another pasture between the stables and the polo barn. At left, an unidentified woman sits on horseback in this pasture. (Above, Fort Bragg; at left, Louise Alabaster.)

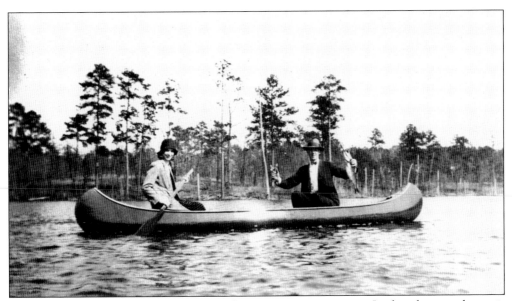

Overhills Lake offered boating, fishing, and swimming opportunities. In this photograph, a pair of well-dressed boaters, aboard a canoe in the 1920s, display their catch, a Jack fish (chain pickerel). The lake was a popular fishing spot for decades. Early accounts suggest the lake was stocked as early as the opening days of the club. The lake would continue to be stocked, and the fish population was monitored. (W. E. Bruce Jr.)

Despite the presence of water moccasins and cool water temperatures, the lake was a popular swimming spot. Along the earthen dam, a white-and-red-painted concrete bathhouse was constructed around 1920; an austere, functional interior housed two changing rooms, one for boys and one for girls. This photograph dates to 1996, but the bathhouse's modern appearance remained indicative of its historical design. (Fort Bragg.)

In these photographs, a group of unidentified women set sail from an impromptu landing along the south side of Overhills Lake around 1925. The small, peaceful lake accommodated canoes and rowboats throughout its history. Eventually, a small, red boathouse and launching point would be built in the vicinity of these photographs. In later years, the lake featured a boardwalk that meandered through the cypress forest on the upper, swampy end, providing beautiful scenes and sounds for nature walks, especially for those who loved bird-watching. A walking trail encircled the lake as well. (Both, Louise Alabaster.)

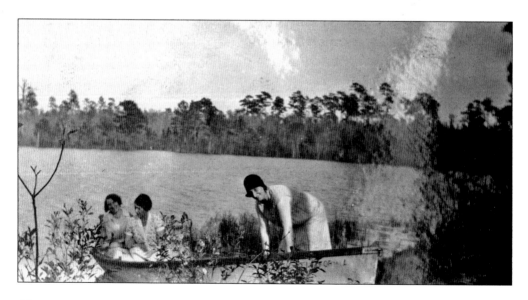

At Overhills, tennis was an early recreational offering for guests. A clay court was built in the 1920s, and in the 1930s, the court was resurfaced using cork. Eventually, the court would be relocated and a modern asphalt surface created. In these 1920s photographs, a group of tennis players enjoy conversation at the net. In both photographs, Albert Alabaster stands on the right; his children Bert and Doreen are on the left. The others remain unidentified. Preceding golf in American history, tennis became a country club sport in the late 19th century. Its inclusion at Overhills reflects an effort to diversify club offerings beyond hunting. (Both, Louise Alabaster.)

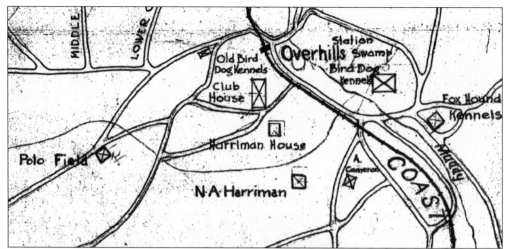

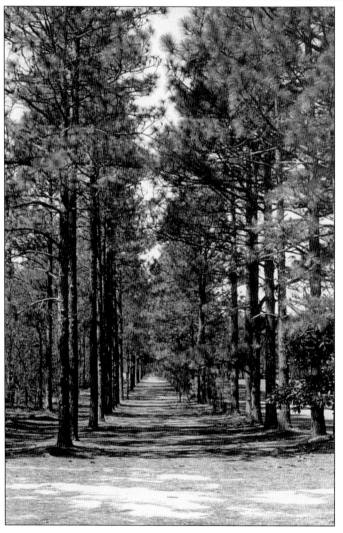

In the 1920s, polo was added to Overhills. A polo field was built along the No. 15 fairway of the golf course (see location on above map). While the creation of the Circus is attributed to Percy Rockefeller, polo is associated with William Averell Harriman, who played polo on a 1928 U.S. championship team. Polo players rode from the polo barn or Clubhouse out through a pine allee (left). Little record exists of polo. At least some team competition was likely held with army officers at Fort Bragg and the Pinehurst Club. (Above, Fort Bragg; left, NC SHPO.)

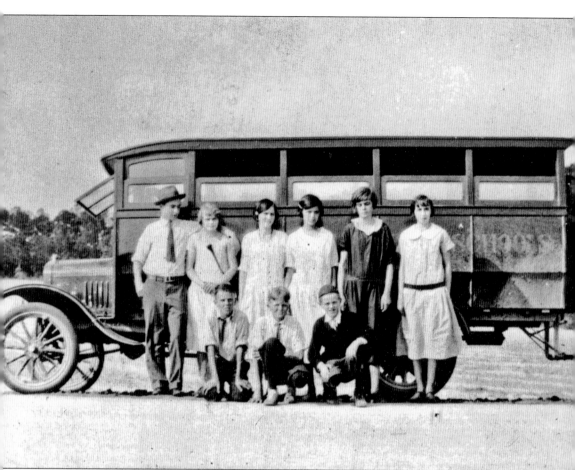

As Overhills hired workers, it also gained families. By the 1920s, a school bus ran a regular route through the estate. Most Overhills children attended a school near the Lindley Nursery until 1926, when Harnett County consolidated the smaller country schools. After the nursery school, children in Harnett County, at least white children, attended Anderson Creek School near Lillington. Schools remained racially segregated in North Carolina until the late 1950s. In this *c.* 1925 photograph, school-age children from Overhills pose in front of their bus. The young man on the left, possibly Andrew Jackson Sr., is likely the driver, a role typically filled by a high school student. A closer look shows his arm around the girl to his left, who looks less than pleased. The writing on the bus is blocked by the students; only the word "schools" can be seen on the right. (Louise Alabaster.)

As a remembrance of the happy days spent together in the schoolroom, this souvenir is presented to you with the best wishes of your teacher.

Bennie and his sister Margaret, children of Luther and Ada Jackson, attended the nursery school in 1924. In that year, Bennie completed fourth grade, and Margaret completed second grade. Their teacher, Margaret McNeil, taught them in the small schoolhouse with other local children. Some of these students were residents of Overhills, children of employees of Lindley Nursery, or from the Anderson Creek area. Called "Valley Mount" on a *c.* 1925 map, this school was built around 1911 by Atlas Simpson Davis, manager of the Lindley Nursery. In addition to its use as a school, the three-room building later served as a church and a meeting house. (Both, Brenda Mathews Hollenberg.)

### My Gift

I SHOULD like to send you a sunbeam,
  Or the twinkle of some bright star,
  Or a tiny piece of a downy fleece,
That clings to a cloud afar.

I should like to send you the essence
  Of a myriad sun-kissed flowers,
Or the lilting song that floats along
  Of a brook through fairy bowers.

I should like to send you the dewdrops,
  That glisten at break of day,
And then at night, the eerie light
  That mantles the milky way.

I should like to send you the power
  That nothing can overthrow,
The power to smile and laugh the while
  As journeying through life you go.

But these are mere fanciful wishes.
  I'll send you a God-speed instead,
And I'll clasp your hand and you'll understand
  The things I have left unsaid.

LEARNING by study must be won;
  'Twas ne'er entailed from sire to son.
                                        *Gay.*

PRESENTED TO

*Margaret Jackson*

Grade  *2nd*

School  *Nursery*

By  *Margaret McNeill*
                          Teacher

*May  16*  192 *4*

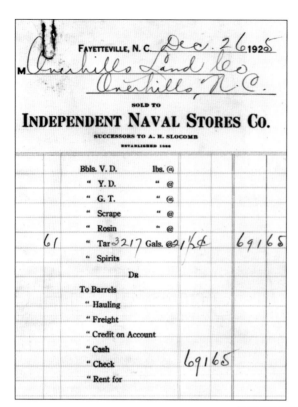

	Bbls. V. D.		lbs. @				
	" Y. D.		" @				
	" G. T.		" @				
	" Scrape		" @				
	" Rosin		" @				
61	" Tar 3217	Gals. @21½¢			691 65		
	" Spirits						

FAYETTEVILLE, N. C. *Dec. 26* 1925

M *Overhills Land Co*
*Overhills, N. C.*

**SOLD TO**

## INDEPENDENT NAVAL STORES CO.

SUCCESSORS TO A. H. SLOCOMB

ESTABLISHED 1866

Dr

To Barrels
" Hauling
" Freight
" Credit on Account
" Cash
" Check        691 65
" Rent for

A continuation of an old industry, tar production was practiced at Overhills into the 1930s. While the naval stores industry faded regionally after the late 19th century, tar continued to be economically viable for some Overhills farmers. This 1925 receipt records payment for tar produced on the estate. Tar was extracted from longleaf pine lightwood that was slowly and carefully burned in an earthen kiln. (Fort Bragg.)

By the 1930s, the regular staff employed at Overhills included the superintendent, a bookkeeper, a dairyman, and others. Many of those positions were called for in the 1920 superintendent's report. This 1933 payroll list identifies employees other than farm workers. Those listed here worked primarily around the Hill. Others such as the hunt staff would have been paid by different accounts, for example, Percy Rockefeller's Overhills Hunt Country and Kennel Department. (Fort Bragg.)

EMPLOYEE'S OF THE OVERHILLS LAND COMPANY OTHER THAN FARM EMPLOYEE'S AS OF JANUARY 1ST 1933.

NAME.	OCCUPATION.	MONTHLY RATE.	
Bruce,W.B.	Superintendant	200.00	
Gurganious,R.J.	Bookkeeper	75.00	
Darden, Troy	Dairyman	65.00	
Cameron,A.C.	Foreman	60.00	
Alabaster,Bertie	Golf Course Keeper	50.00	
Huffine,D.A.	Forest & Game Warden	15.00	(Part time)
Shaw,A.A.	" " " "	5.00	" "
Murchison,Sam	" " " "	5.00	" "
Jones,Sandy	" " " "	20.00	
McDougald,George	" " " "	30.00	
McRae,Mary	Cook Etc.	25.00	
Lundy,E.C.	* Carpenter,Painter Etc.	20.00	(Day work)
Holder,W.V.	* " "	20.00	" "
Williams,John Sr.* Laborer		15.00	" "
Smith,John Sr., * "		15.00	" "
Smith,John Jr., * "		18.00	" "
McDougald,Miller * "		18.00	" "
Alderman,Henry * "		15.00	" "
Alderman,Garland * "		15.00	" "
McRae,Neil * "		12.00	" "
Miscellaneous * "		20.00	" "
Total pay roll		$718.00	

* Estimated monthly rate.

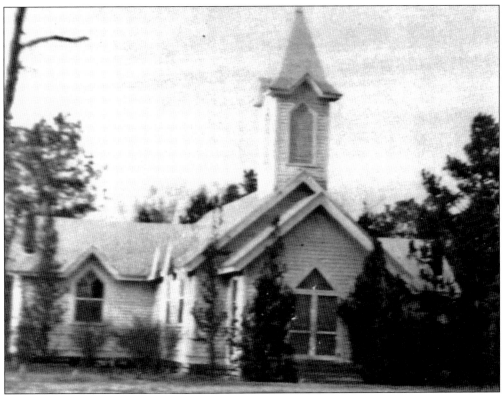

The Church of the Covenant in Manchester, North Carolina, was a small Presbyterian church attended by several Overhills employees and, on occasion, some of the Rockefeller family. The modest single-story, wood-frame church had a manse across the road, which was constructed with funds provided by Percy Rockefeller. At least two Overhills employees served as church elders, W. B. Bruce and A. S. Davis. (Bruce Strauch.)

Walter Edward Bruce Sr. and Annie Vernice Harris married on February 19, 1932, at the Church of the Covenant. Rev. Eugene Alexander and Rev. Watson Fairly presided over the ceremony. The wedding party included Overhills residents W. B. Bruce, Bertie Alabaster, George Whitford, Lula McCormick, and Virginia Bruce. Non–Overhills residents included Katherine Harris, Smyth Puckett, Robert Bruce, and J. A. Cade. (W. E. Bruce Jr.)

Mr. and Mrs. Ausband Gentry Harris
of Fayetteville
request the honour of your presence
at the marriage of their daughter
Annie Vernice
to
Mr. Walter Edward Bruce
on Friday, the nineteenth of February
at half after seven o'clock
at The Church of the Covenant
Manchester, North Carolina

Reception following ceremony at
Overhills, Harnett County

Following the ceremony, the Bruces celebrated their marriage with family and friends at a reception in the Overhills Clubhouse. A newspaper article recounts the event in detail, reporting that pines, palms, and cut flowers decorated the Clubhouse's interior. Guests dined on sandwiches, cake, cream, and coffee, and enjoyed square dancing the Virginia reel. In this photograph, Walter Edward and Vernice Bruce Sr. pose on their wedding day in front of Percival Rosseau's studio. They celebrated their honeymoon in Florida before returning to live in their new home in Overhills. Below, Bruce poses on a bench in his wedding tuxedo. (Both, W. E. Bruce Jr.)

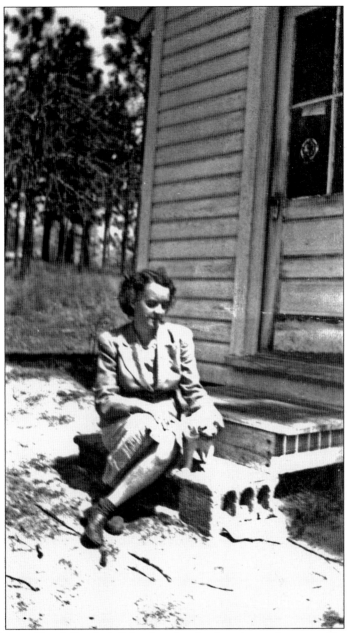

In the early days at Overhills, daily life often involved a trip to the post office. In the 1920s and 1930s, mail and telegrams were dispatched from and delivered to the Atlantic Coast Line passenger station. By 1944, the mail no longer came "on the fly" (by train), and Walter Edward Sr. built a small one-room post office for his wife, Vernice, the postmistress from 1944 to 1976. This post office stood down the hill from the Bruces' house, which overlooked the Circus. Everyday Vernice Bruce sorted the mail into boxes and enjoyed the company of residents who came to pick up their mail and socialize. Mail was delivered to this small post office by automobile until 1976, when Vernice Bruce retired. The last day of issue for the Overhills Post Office was June 18, 1976, after which mailboxes were installed for residents. In this photograph, Vernice sits on the post office steps with the family's new puppy around 1948. (Patricia Penny.)

Primary methods of communication to and from Overhills included letters sent through the U.S. Postal Service and telegrams sent via Western Union. R. J. Gurganious operated the telegraph office, located in the train passenger station. He also served as postmaster from 1917 to 1926 and from 1935 to 1942. This item of insured mail, which Gurganious would have received, was included with the Articles of Incorporation for Overhills Farms, Inc. (Fort Bragg.)

Communication between club members and Overhills' staff via telegrams and letters was critical for planning visits during the busy season. Correspondence involved requesting menu items, train reservations, and specifying the expected number in the parties. In this 1932 telegram, Isabel Rockefeller asks Thelma Bruce to buy specific food items, including string beans, lettuce, and chicken, when "marketing Wednesday." (Fort Bragg.)

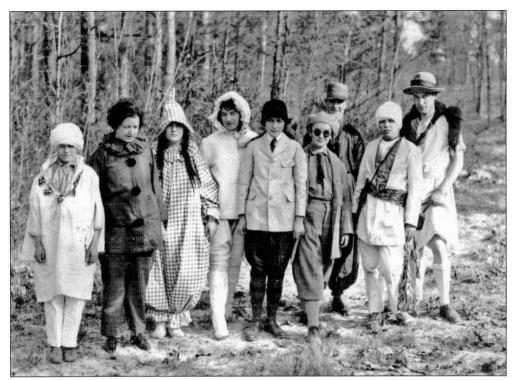

Throughout the 1920s, Overhills' staff enjoyed community celebrations, including square dances and masquerade parties. These c. 1925 photographs reveal some of the eclectic, elaborate, and creative costumes worn by adults and children. Participants dressed as Uncle Sam, clowns, horseback riders, and in nonspecific outfits involving grass skirts, a gigantic heart on a shirt, and a dress strung with playing cards. People exchanged costumes with each other from one party to the next. Parties were held in the Clubhouse, where the social room provided a large, dynamic gathering space. Though these people are unidentified, the majority were Overhills residents. (Both, Louise Alabaster.)

Although a Southern refuge from the harsh Northern winters, Overhills was not immune to snowstorms. Visitors may not have hoped for snow, but residents delighted in the wintry weather, an uncommon sight at Overhills since it lay in the warm Sandhills region. As such, it clearly inspired photographs by witnesses to the beautiful white scenery. These photographs capture the amusement of snow, as well as its beauty. Above, Overhills residents enjoy building a snowman and having a snowball fight before it melts completely in front of the Alabaster house on March 12, 1924. Below, Bert Alabaster plays with his German shepherd during a *c.* 1930 snowfall. (Both, Louise Alabaster.)

## CHRISTMAS LIST 1932.

NAME.		AGE.1933	GIFT.	
+ COBLE C T		—	BLACK SWEATER	Q NO $10
"	MRS C T		POCKET BOOK	
"	CATHERINE	10	DRESS –JERSEY	Paper dolls + scirsor
DARDEN TROY			TAN SWEATER	
"	MRS TROY		SPORT SWEATER	
"	RUTH	8	DRESS–JERSEY	Pocket-book –
"	FRANK	7	PULLOVER SWEATER	Harmonica
"	ISABEL	6	DRESS	Tea set
"	THERESA MARIE	4	2 DRESSES	Doll
"	DAVID	2	COAT	Red Truck
CAMERON A C			BLACK SWEATER	
"	MRS A C		POCKET BOOK	
"	LONA MAE	14	JUMPER	Beads
"	RUBY	11	JERSEY DRESS	Paper dolls scissors
"	ARCHIE JR	8	SWEATER	Bolo
Dorothy ann MCKAY	MRS	8 mo	BLUE SWEATER	

For many years in the 1920s and 1930s, Overhills' employees and neighbors celebrated Christmas together with a party in the Clubhouse provided by the Overhills Land Company, largely the effort of Isabel Rockefeller. The shareholders of the company and the members of the shooting syndicate contributed to the party fund. Letters with well wishes to the families accompanied the shareholders' donations. Each adult and child who attended the party received at least one gift. Typical presents included an article of clothing or outfit accessory. Children received toys in addition to clothes. Shown here is a selection from the 1932 Christmas list, with later additions in pencil handwriting. The lists generally noted the ages of the children. Some of the 1933 additions are paper dolls and scissors for Ruby Cameron and Catherine Coble, a red truck for David Darden, and a harmonica for Frank Darden. Added to the Cameron family is eight-month-old Dorothy, who was born in 1933. (Fort Bragg.)

Isabel Rockefeller, known for her generosity, regularly sent Overhills' employees and their families to Myrtle Beach, South Carolina, for a summer vacation. She rented a house for the month of August, and groups of families visited for one-week-long stays. Families invited to vacation at the beach included tenant farmers such as the Allgoods and the Holts. Families other than tenant farmers included the W. E. Bruce family, the W. B. Bruce family, and the A. C. Cameron family, as well as many others. In this c. 1933 photograph, (from left to right) Sabra Coble, Vernice Bruce holding her son Edward Jr., Virginia Griffith, and Katherine Coble pose in the shallow surf. Below, Edward Jr. plays in the sand with his mother c. 1933. (Both, W. E. Bruce Jr.)

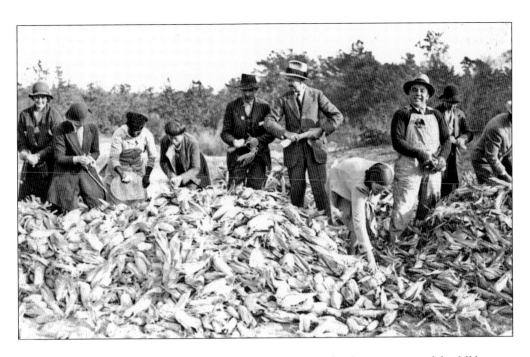

A rural Southern tradition dating to the 19th century, corn shucking was part of the fall harvest at Overhills. For many employees, it became a community event. Neighbors gathered from on and off the estate, helping to husk large piles of corn, amounting to about 800 bushels in 1933. Isabel Rockefeller funded a barbecue for the huskers. W. B. Bruce coordinated the annual event in the early 1930s, ordering the pigs, side dishes, drinks, and plates. These photographs show the employees hard at work with the corn. In the background of the photograph below is the big red barn behind the A. S. Davis house. (Above, Sandy Hemingway; below, W. E. Bruce Jr.)

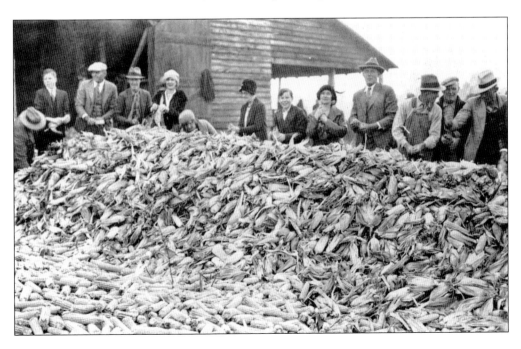

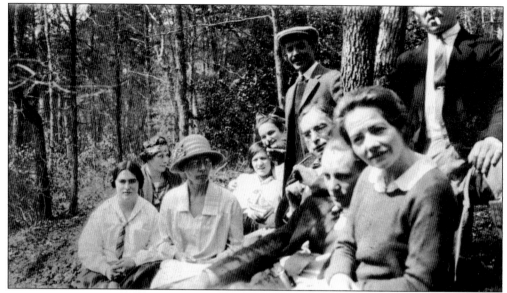

A special outing for Overhills' employees and friends in the 1920s might have included a picnic on the outskirts of the estate. In these 1925 photographs, a group of well-dressed friends gathers at the "Haunted House," the location of an abandoned 19th-century home along the Lower Little River. This was the former residence of John Lamont, a Highland Scot immigrant, who operated a toll ferry across the river. The Lamont land, along with many other family-owned properties, was acquired to amass the acreage for Overhills in contiguous tracts. For the day-trippers seen here, this old site offered a nice view of the river as well as an interesting historic landmark. (Both, Louise Alabaster.)

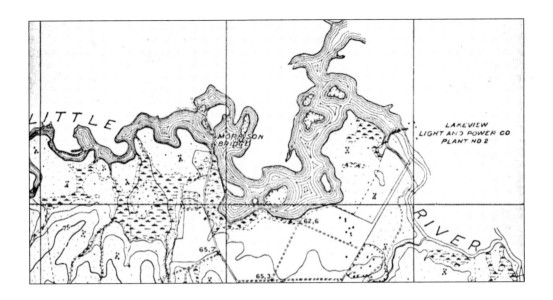

Despite the isolated, rural location of Overhills, in the early 1920s, the estate received electricity, at least in some locations. The earliest power source came from the hydroelectric plants on the Lower Little River, one of which is depicted above on a 1919 map of Camp Bragg prepared by the U.S. Army. At Overhills, power was supplied to the Clubhouse, cottages, kennels, train station, and horse stables. In these early days, power was not reliable, and correspondence identifies interruptions to the electric current. These buildings received electricity years before surrounding tenant farmers' houses. The people below sit on the Clubhouse porch during the daylight around 1925, but at night, they could use electricity, as indicated by the lightbulb on the ceiling. (Above, Fort Bragg; below, Louise Alabaster.)

Hope Mills,N.C. Sept.10.1924.
R.F.D.No.2 Box No.3.

Capt.F.N.Miller,

Westbury,N.Y.

Dear Sir:-

    I would like to get the Old place from you the Haire Town
place beyond the Nursery where I lived at up until last spring. I
understand this house have been covered and can be used now.Please
let me hear from you at once if I can get same and under same
conditions as I lived there before.Thanking you for prompt reply.

N H Townsend

As the Overhills Land Company expanded its holdings and operations, it sought farmers to work on halves, the 50-50 share system. Farmers received housing and land, fertilizer, and seed, in turn providing their labor and half of their crops to the company. In this letter, a former farmer inquires about his old property. Tenant farming shifted to a company operation in the late 1970s. (Fort Bragg.)

Whether tenant or company-run, farming continued throughout Overhills' history. The presence of arable land was noted as early as 1911, and by the 1920s, crops included cotton, tobacco, and corn. Over time, tobacco became the most popular crop. Employees constructed tobacco barns, an increasingly common sight on the farm fields. This row of tobacco barns stands behind the former nursery manager's house. (NC SHPO.)

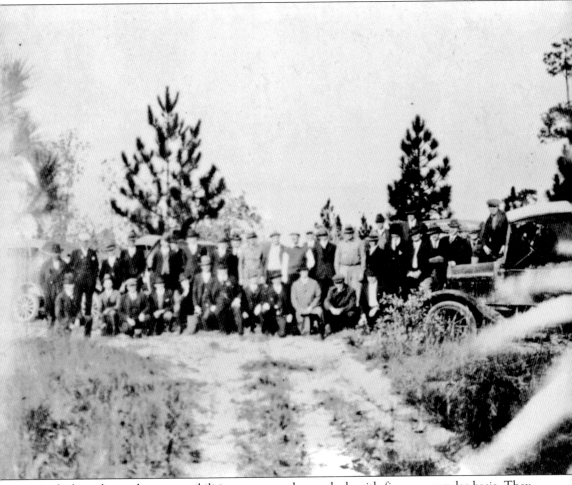

Aside from day-to-day responsibilities, some employees dealt with fire on a regular basis. They could be called to fight wildfires, a common threat in the Sandhills. Firebreaks were cut in the 1920s, and employees conducted burns across the estate in order to reduce the risk of fire. The Overhills Land Company owned its own fire engine, which was equipped with rakes, buckets, brush hooks, and a trailer attachment. In addition, Overhills cooperated with local efforts and state authorities to combat wildfire. The North Carolina state forest warden corresponded with Capt. Frank Miller, hoping to encourage Overhills' participation, particularly because the property accounted for much of the undeveloped, forested area in the region. Overhills joined with the Cape Fear Fire Protection Association, which created a network of fire wardens and provided fire protection at 1¢ per acre in 1931. For Overhills, this totaled $300 for 30,000 acres. Shown in this photograph are fire wardens at Overhills on September 4, 1924, gathered for a forest wardens' meeting. (NC Archives.)

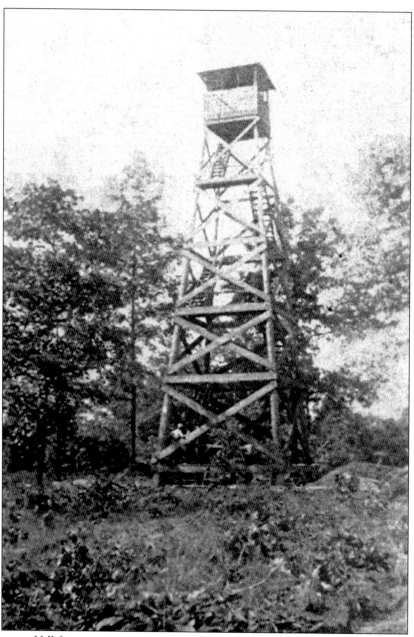

The Cameron Hill fire tower, constructed in 1926 and shown above, was part of the Cape Fear Forest Protection Association. Located northwest of the Overhills property, the tower provided forest wardens with a convenient, accessible lookout. Overhills granted a right-of-way access for the purpose of installing a telephone line to facilitate fire notification from the Cameron Hill fire tower to McCormick's Bridge via Fairley's Store on Overhills land. This telephone line was installed in the Clubhouse in 1927. It also reached the Lindley Nursery and the Long Valley Farm. The Overhills Land Company constructed a fire tower in 1926; however, as the forest warden noted, it was likely to sink into the ground since it lacked a cement foundation. Fire wardens at Overhills included W. B. Bruce, George McDougald, Sam Murchison, and Sandy Jones. (Fort Bragg.)

# Five

# PEOPLE

As much as Overhills' history involves the story of a hunt club, of recreation and leisure in the Roaring Twenties, of a prestigious family's retreat, it is also a story of people. For the individuals and families who inspired, invested in, managed, and visited the estate, Overhills was a place where memories were created, adventures were led, and solitude was prized. For many others, Overhills was their home, backyard, and part of a community. The story of Overhills includes its founders and patrons, and its caretakers, as well as the laborers, farmers, housekeepers, cooks, and their families.

Most of the people associated with the earliest days of Overhills remain elusive; photographs and biographical information are sparse. Signatures in guest books reflect numerous people who came and went. This chapter, while not comprehensive, is dedicated to those who stayed and those who had significant influence in the development of Overhills.

```
                    Wm. Wickham Hoffman
                      55 Wall St.
                    New York, N.Y.

                                        May 20, 1929

        Mr. Windsor T. White
        1652 Union Trust Bldg.
        Cleveland, Ohio.

        My dear Mr. White:

              Many thanks for your letter of the 16th
        notifying me of my election as a member of the
        Overhills Shooting Syndicate.    I have been to
        Overhills on various occasions and have shot there
        in the early days with Sheriff Joerdan before the
        clubhouse was built.

              I have always thought the place was quite
        unique and consider myself very fortunate to have the
        privilege of being a member.

              I still keep up a small shooting preserve
        outside of Greensboro which my father started over
        thirty years ago but it is very hard to preserve
        this as we used to be able to do it before the days
        of cheap motor cars, cheap guns and good roads.

                            Very truly yours,

                            (Signed) W. W. Hoffman
```

Born a minister's son in Orange County, North Carolina, in 1859, James Francis Jordan moved to Guilford County in 1890, where he would serve as sheriff, establish a business in tobacco trade, and eventually pursue real estate for a living. The latter interest, combined with a skill and appreciation for the outdoors, led to Jordan's involvement at Overhills. He enjoyed a strong reputation as a sportsman and hunt guide. At Overhills, Jordan was effective in building relationships with many non-local businessmen with whom he became acquainted through hunting trips. Jordan was described in a 1911 newspaper article as "a man of few words, but much action." In his personal history of Overhills, Avery Rockefeller notes that Jordan's "dynamic personality" made the country club a "great success." Eulogized in the leading editorial of the *Greensboro Daily Record* in 1919, Jordan's unexpected death was called "sad news" for the entire city. He was remembered as "the well-known athlete, sportsman, [and] lover of nature." (Fort Bragg.)

The son of a wealthy Chicago businessman, William Kent (1864–1928) was raised in rural Northern California. After graduating from Yale in 1887, Kent pursued his father's business interests before turning to politics and social reform. A California congressman from 1911 to 1917, Kent was a Progressive Republican who championed conservation values. It was during the years Kent spent in Washington, D.C., that his relationship with James F. Jordan developed. As he was an avid sportsman, Kent's passion for the outdoors, combined with his background in real estate, most certainly influenced his interest in Overhills. His Progressive political ideals led him to numerous conservation efforts, and he is perhaps best remembered as a philanthropist who donated land that would become Muir Woods, one of the earliest national monuments in the country. In 1903, Kent commented on the degrading nature of cities, expressing the need to seek recuperation and strength in nature and to escape to wilder environments. This sentiment was likely shared by most of Overhills visitors throughout its history. (Martye Kent.)

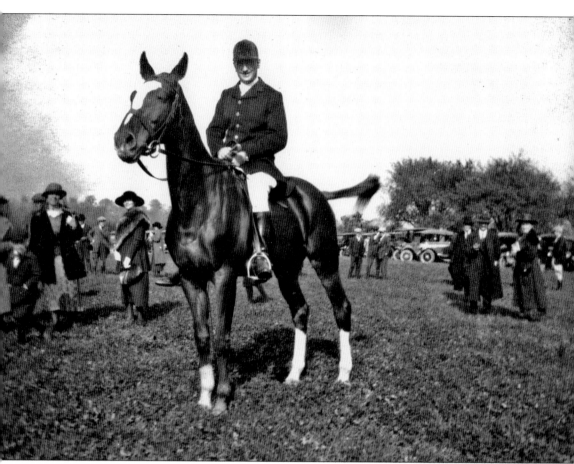

Percy Avery Rockefeller (1878–1934) was born in Greenwich, Connecticut, the son of William and Almira Goodsell Rockefeller. After graduating from Yale in 1900, Rockefeller began a career as a capitalist and financier, serving as a director on several corporations and some 51 companies at one point in his life. Involved in his father's Standard Oil Company and National City Bank, among others, Percy invested in Air Reduction, Inc., his most noted success. Foxhunting was his passion, and by the 1920s, Overhills came under his leadership. Although Rockefeller's parents were members of the Jekyll Island Club in Georgia, Percy chose the North Carolina estate for himself. Rockefeller married Isabel Goodrich Stillman, daughter of First National Bank president James Stillman, in 1901. Their five children would inherit Overhills. This photograph of Rockefeller mounted, ready for the hunt, was taken at Overhills in 1927. (Patricia Penny.)

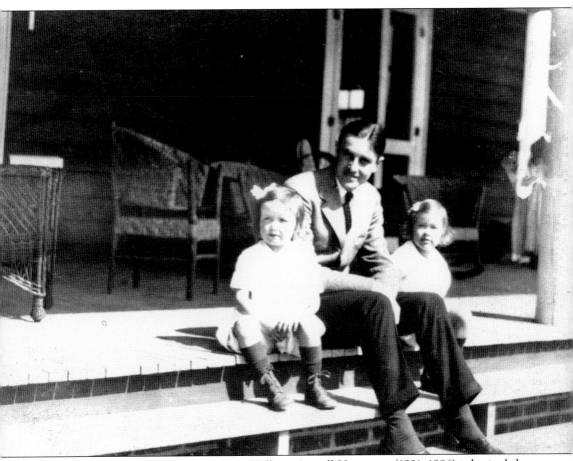

Soon after graduating from Yale in 1913, William Averell Harriman (1891–1986) inherited the massive fortune of his father, E. H. Harriman, a railroad baron. Averell Harriman was successful in several business endeavors, including shipping, railroads, and banking. By the 1930s, Harriman began to pursue a significant and lengthy political career, becoming the governor of New York, ambassador to Great Britain and the Soviet Union, and a diplomat involved in several presidential administrations. A friend and business partner of Percy Rockefeller, Harriman spent time at Overhills as a young man, hunting and playing polo. Following his first Overhills visit in 1916, within a few years, Harriman had invested in the club, both financially and personally. He brought his family to Overhills as well. His brother, Roland Harriman, was a regular visitor at the estate. In this *c.* 1920 photograph, Averell Harriman sits on the front porch of his cottage with his two daughters, Kathleen (left) and Mary. (Kathleen Mortimer.)

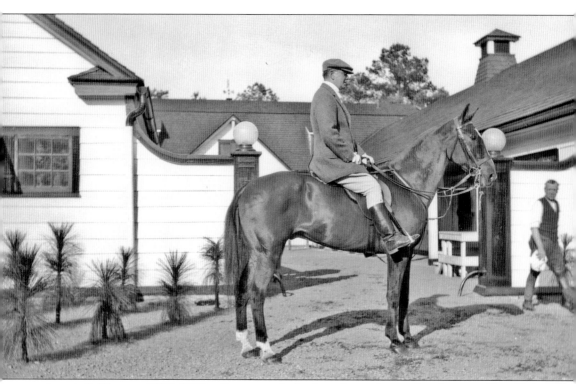

Joseph B. Thomas (1879–1955), a Bostonian by birth and a professional architect in New York, was a keen foxhunter, a passionate breeder of hounds, and founder of the American Foxhound Club (eventually the Foxhound Club of North America). Thomas's extensive knowledge of hounds and foxhunting is illuminated in his 1928 treatise *Hounds and Hunting through the Ages*, in which Overhills is referenced numerous times. Thomas owned a large country estate called Huntland in the Virginia Piedmont, near Middleburg, where he was Master of the Piedmont Fox Hounds in the 1910s. He was especially successful in breeding and supplying packs of hounds, influencing a major increase in the number of packs active in the 1920s. Though not a shareholder in the Overhills Land Company, as a friend of Percy Rockefeller, Thomas hunted at Overhills regularly in the 1920s and supplied the pack each winter. In this photograph, Thomas appears on horseback in front of the hunt stable in the early 1920s. (Photograph by L. S. Sutcliffe; Ken Grayson.)

## OVERHILLS LAND COMPANY
### OVERHILLS, HARNETT COUNTY
### NORTH CAROLINA

LIST OF STOCKHOLDERS ENTITLED TO VOTE AT THE ANNUAL MEETING
HELD AT THE OFFICE OF THE COMPANY, DURHAM, N.C. 14TH DAY OF
MAY 1935 AT 11 A.M.

. . . . . . . . . . . . . . . . . . . . .

NAMES	NO. OF SHARES
W. E. COREY	160
P. A. ROCKEFELLER	1119 ✓
W. A. HARRIMAN	158 ✓
WALTER CAMP, JR.	1
* S. F. PRYOR	160 * ✓
ESTATE OF WILLIAM G. ROCKEFELLER	160 ✓
GEORGE ADAMS ELLIS	1
E. ROLAND HARRIMAN	160 ✓
ROBERT R. KING	1
FREDERIC W. ALLEN	160
TOTAL	2080

* TRUSTEES U/W P.A.ROCKEFELLER OR THEIR
  NOMINEES.

The Overhills Land Company formed in 1921, serving as the managing body until 1938 when Overhills Farms, Inc., was established. The men behind the Overhills Land Company were generally friends and business partners, most with Yale roots. The stockholders of the Overhills Land Company, as identified in this 1938 list, included 10 men, three of whom owned only a single share. Equal shares were held by six men, while Percy Rockefeller held a significant majority. Beyond Rockefeller and the Harriman brothers. The others on this list include Frederic W. Allen, chairman of the Yale Graduate Rowing Committee for a decade; William E. Corey, president of the U.S. Steel Corporation; Samuel F. Pryor, a New Yorker and chairman of several companies involved in, among other things, steel, shipping, and locomotives, and who served with Percy Rockefeller on the board of directors of W. A. Harriman Company; and Robert R. King, a Greensboro attorney, the only North Carolina resident on the list. (Fort Bragg.)

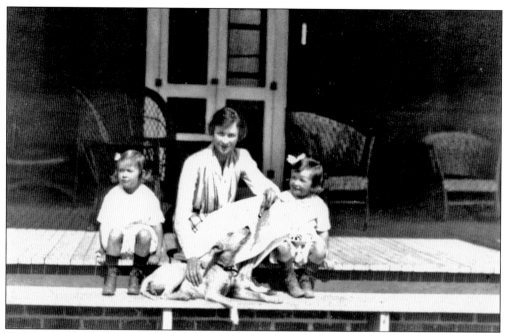

Katherine "Kitty" Lanier Lawrence Harriman, Averell's first wife, visited Overhills frequently throughout the 1920s; she appears several times in the hunt log, participating in bird hunting. Kathleen and Averell married in 1915 and divorced in 1929. Their daughters, Kathleen (right) and Mary (left), were born in 1917. In this photograph, the Harrimans sit on the cottage front porch with their English bull terrier, named Nuisance. (Kathleen Mortimer.)

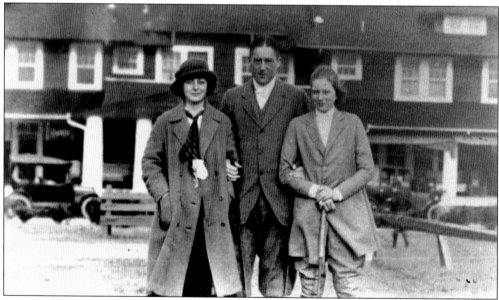

By the 1920s, the family of Percy and Isabel Rockefeller visited Overhills regularly. In this photograph, Almira Geraldine Rockefeller (left), Percy's niece, and Faith Rockefeller (right), who was the fourth child and the third daughter of Percy and Isabel, pose for a photograph in front of the clubhouse around 1920. The man in the middle is Roy Jackson, Almira's first husband. (NC Archives.)

Ethel Peterson, affectionately called "Miss Pete," began working for the Rockefeller family as a teenager in the 1930s, continuing into her adult years. Shown here in the Adirondacks, she often traveled to Overhills with the family. Her skilled artwork was loved by the Rockefellers. Among numerous paintings in family houses, her whimsical paintings of birds and dogs graced the children's baths in Croatan. (Ann Elliman.)

A respected artist, Percival Leonard Rosseau (1859–1937) was raised in rural Louisiana before living and studying art in Paris. Returning home during World War I, Rosseau befriended Percy Rockefeller, whose patronage led Rosseau to paint hunt scenes in his own Overhills cottage and studio in the 1920s and early 1930s. His paintings are celebrated for the depiction of dogs hunting against an Impressionist-influenced landscape. Above is Rosseau's signature from the Overhills guest book in 1924. (Fort Bragg.)

The legacy of Percy and Isabel Rockefeller at Overhills would span five decades of the quiet country estate. This elegant, forested place—rich in history and full of solitude—would be inherited by their five children: Isabel, Avery, Winifred, Faith, and Gladys. The family grew throughout the 20th century, and Overhills continued to be a special destination. In total, five generations of Rockefellers enjoyed the estate, roughly three of those generations coming of age there and eventually drawing the place to the hearts of their own children. This family photograph of the Rockefellers, taken in the Adirondack Mountains, shows some of the family who came to call Overhills their own. From left to right, they are Faith Rockefeller, Percy Rockefeller, Ann Rockefeller, Isabel Stillman Rockefeller, unidentified, Avery Rockefeller Jr., Avery Rockefeller, and Anna M. Rockefeller. (NC Archives.)

The only son of Percy and Isabel Rockefeller, Avery Rockefeller Sr. was born in 1901. With his sisters, he first visited Overhills as a child and would return regularly throughout his life. When his parents passed away in the 1930s, Avery succeeded his father as the leading figure for Overhills. After retiring in 1967, Avery and his wife, Anna, spent months at a time at the estate, the most residential presence by family members throughout Overhills' history. Becoming the president of Overhills Farms, Inc., with his brother-in-law Frederic W. Lincoln Jr. as vice president, Avery maintained a leadership role into the 1980s. While hunting records reveal a fondness for bird hunting as a young man, in later years, Avery enjoyed horseback riding and birding. Both he and Anna were naturalists. In this photograph, Avery and Anna sit in the living room of Bird Song, the last and largest house built and their seasonal home. Avery passed away at Overhills in 1986. (Sandy Hemingway.)

This photograph shows some of the frequent visitors, all Rockefeller family and friends, to Overhills during the 1920s and early 1930s, gathered for a photograph on the golf course. Pictured are (order unknown) Freddy Lincoln, Helen and Skinny Lawrence, Isabel R. Lincoln, Gil and Betty Nichols, Hope L. Coombe and Reggie Coombe, and Helen and Godfrey Rockefeller. (Sandy Hemingway.)

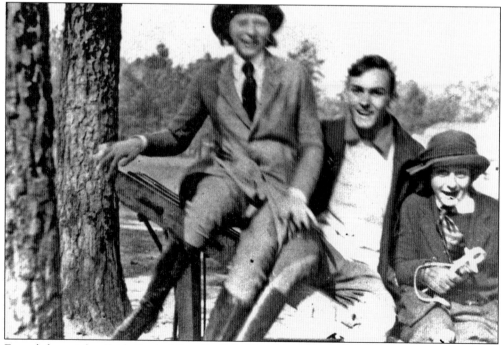

From left to right, Faith Rockefeller, Griffith "Fritz" Mark, and Almira Rockefeller are posed dressed in their riding clothing. Note the jackets, tall riding boots, and the whip in Almira's hand. She was the only daughter of the five children of William Goodsell Rockefeller, Percy's brother. Fritz is the brother of Anna, who became Avery Rockefeller's wife. (NC Archives.)

Before moving to Overhills, Albert Alabaster worked and lived across the world, including places such as Greece, England, and South Africa. While in Greece, Alabaster married Lettie Marie Turner in 1907. They had three children: Theodore "Ted," Horace (1908), Doreen "Dolly" Nora (1909), and Albert "Bert" Alexander (1913). Lettie and the children moved to Overhills in 1921, where Alabaster worked for Percy Rockefeller. The family lived at Overhills until 1934, after which they moved to Fayetteville, North Carolina. At right, Alabaster stands behind the Covert as he trains his terriers around 1925. Below from left to right, Bert, Dolly, and Ted Alabaster pose in front of their house at Overhills in about 1923. (Both, Louise Alabaster.)

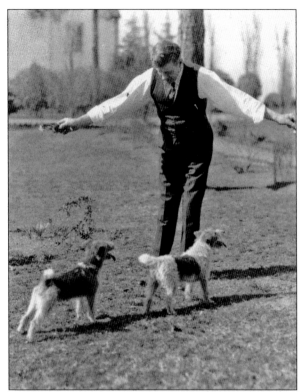

Certain employees at Overhills enjoyed such longevity that they became synonymous with the estate. More than anyone, William Bryan "W. B." Bruce was such a figure. He first came to Overhills from Middleburg, Virginia, in 1919 with experience as a steeplechase rider and worked for Percy Rockefeller. After Captain Miller resigned as superintendent in 1932, Bruce took over the position, one that he held until his death in 1972. Over the course of his tenure, he earned the respect of everyone at Overhills and kept the Overhills Land Company and Overhills Farms, Inc., operating efficiently and seamlessly. At left is a portrait of a young W. B. Bruce. Below, he and a man identified as O'Dwyer (left) are dressed for a fox hunt in the middle of the Circus between the hunt stables and kennels. (Both, Bruce Strauch.)

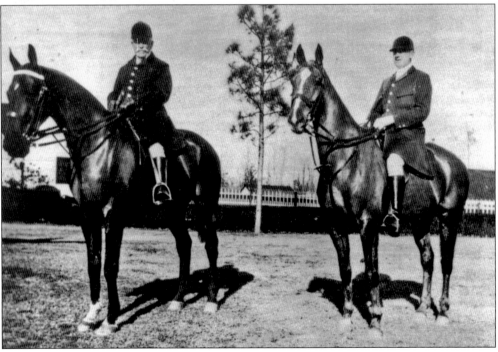

Raised in Harnett County, Thelma Puckett married W. B. Bruce and moved to Overhills, where she lived most of her life. After W. B. died in 1972, Thelma continued to live at Overhills until the mid-1980s, when she left. Thelma Bruce played a critical role managing domestic affairs at the estate. This *c.* 1930 photograph shows Lillian ?, Thelma, and Colleen ? in front of the clubhouse. (Bruce Strauch.)

W. B. and Thelma Bruce did not have any children of their own, but together they raised two nieces, one from each side of the family. Virginia Griffith moved from Virginia to Overhills in 1926 at the age of 10. Dorothy Bruce moved to Overhills a few years later. Here Virginia stands outside the Clubhouse, dressed for her uncle Edward Bruce's wedding in 1932. (Bruce Strauch.)

Archie Cameron and Annie McKay married in the late 1910s. They were both from the area around Cameron, North Carolina, and moved to Overhills c. 1920. Archie worked as the chauffeur at first and became an institutional figure at the estate, spanning decades of change. The Camerons first lived in the house behind the polo barn and later in the house nearest the freight depot. Archie eventually worked as a muleskinner and farm manager alongside Supt. W. B. Bruce. The Camerons had four children: Lona Mae, Ruby, Archie Jr., and Dorothy. When Archie died in 1975, many of the memories of the early days at Overhills died with him. He and W. B. Bruce had worked there longer than any other employees. Aside from Overhills residents, many people in surrounding communities knew Archie well and had been recipients of his generosity and care. Annie continued to live at Overhills into the 1980s. This is their wedding picture. (Betty Deere.)

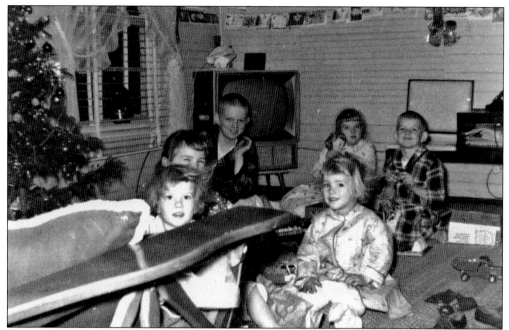

The Rockefeller family typically traveled to Overhills the day after Christmas, which allowed employees to celebrate the holidays with their families. In this photograph, the children of Ruby Cameron Bull open Christmas presents in their Grandma and Grandpa Cameron's house. The children and grandchildren of Archie and Annie Cameron often returned to visit them at Overhills. (Betty Deere.)

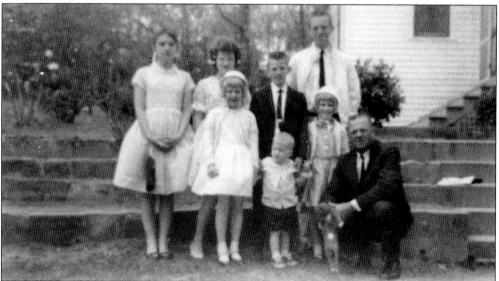

Not all of Overhills' residents were employees. Ruby Cameron married Technical Sgt. Walter Bull Sr. of the U.S. Army. They lived intermittently at Overhills during the 1950s to the 1970s, whenever Bull was stationed at Fort Bragg. This Easter photograph was taken in front of their house, located above the Circus. From oldest to youngest (pictured order unknown), the children are Walter, Barbara, Kathy, Charles, Betty, Diane, and Byron. Their father kneels on the right. (Betty Deere.)

Willie King began working at Overhills around 1927 in the hunt kennels, where he cooked meals for the hounds. He eventually managed the riding stables for many years. In that role, King became one of the long-term resident employees at the estate frequently encountered by the Rockefellers and their guests. Willie and his wife, Essie, lived above the riding stables. His name appears in the Overhills Land Company payroll lists as a "laborer" until the 1960s. The above photograph shows King outside the riding stables in the 1940s. Below, Willie King stands with a horse around 1958. (Above, Bruce Strauch; below, W. E. Bruce Jr.)

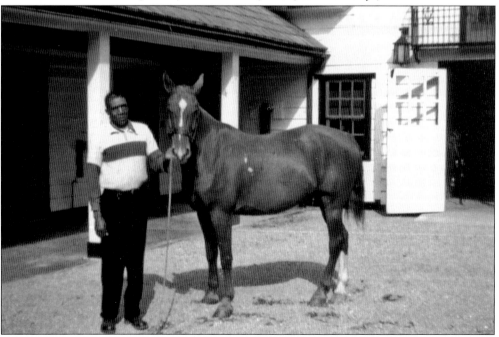

Luther W. Jackson and Ada Coble married in October 1905. They lived at Overhills from 1918 to 1932, during which time Luther worked in the hunt kennels as a dog trainer and hunt guide. They had six children: Andrew (1906), Howard (1907), Charles (1909), Robert (1911), William Benjamin (1913), and Margaret (1916). In this c. 1920s photograph, Luther and Ada are ready to play golf at Overhills. (Ann Collins.)

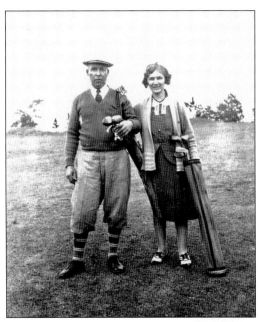

William Benjamin "Bennie" Jackson was born December 13, 1916, and died on November 15, 1928, in a tragic accident at Overhills. He and a friend were playing in an embankment in the sand, digging a tunnel that collapsed, suffocating them. He is buried in the cemetery at the Church of the Covenant in Manchester, North Carolina. In this picture, Bennie rides his favorite pony, Dan Patch. (Brenda Mathews Hollenberg.)

Walter Edward Bruce Jr., son of Walter Edward Sr. and Vernice, was born at Overhills in 1932. He was one of the many children living on the estate in the 1930s and 1940s included on the Christmas list for the parties organized by Isabel Rockefeller. In this 1933 photograph, a baby Bruce plays outside the family house at Overhills. (W. E. Bruce Jr.)

Patricia Bruce, daughter of Walter Edward Sr. and Vernice, was born in 1936. She, like her brother, grew up at Overhills and attended the Anderson Creek School, as did the other children living at Overhills in the 1930s and 1940s. In this photograph, a barefoot Patricia stands outside her family's house in the early 1940s. (W. E. Bruce Jr.)

Thurman Washington began working at Overhills in the 1950s, eventually succeeding Willie King as the riding stable manager. Thurman and his wife, Louise, raised two children, Dennis and Sheila. Known for his unique laugh, horse handling abilities, and involvement in the nearby Bethel AME Zion Church, Thurman was an important community member, both on and off Overhills. He died in 1997. (Dennis Washington.)

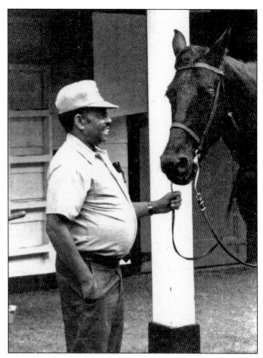

One of the most popular cooks at Overhills, Maggie McDonald worked at the estate from the days of Percy and Isabel Rockefeller. She continued to live at Overhills and work for the family until the 1980s, preparing meals in Croatan and then Bird Song, Avery and Anna Rockefeller's house. In this photograph, Maggie is seated in the Bird Song dining room in her uniform. Sandy Hemingway, bookkeeper from the 1970s through the 1990s, stands behind her. (Sandy Hemingway.)

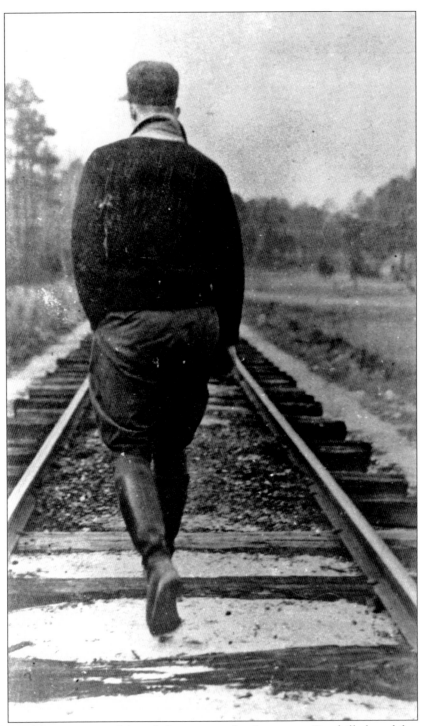

From hunt club to country club and then private family retreat, Overhills lasted for nearly a century and was known by many people from all walks of life. By the late 20th century, however, the Rockefeller family and all of the employees and residents were forced to walk away from the historic country estate when it was sold to the U.S. Army. (NC Archives.)

# Bibliography

Alexander, Frances P., and Richard L. Mattson. "Historic Architectural Resources Survey Report, Overhills Tract, Fort Bragg, Harnett and Cumberland Counties, North Carolina." Prepared for U.S. Army Corps of Engineers, Savannah District, Savannah, GA, 2000.

Brooks, Aubrey Lee. *A Southern Lawyer: Fifty Years at the Bar.* Chapel Hill, NC: University of North Carolina Press, 1950.

Hood, Davyd Foard. "Overhills Historic District." Nomination to the National Register of Historic Places (draft). On file at the North Carolina State Historic Preservation Office, Raleigh, 1992.

"James Francis Jordan," *Greensboro Daily Record*, April 2, 1919.

Nash, Roderick. "John Muir, William Kent, and the Conservative Schism." The Pacific Historical Review, Vol. 36, No. 4, pp. 423–433. 1967.

Overhills Document Collection. Archived collection of records from the Overhills Estate, on file at Fort Bragg, North Carolina.

Rockefeller, Avery. "Brief History of Overhills, Parts I and II." Manuscript on file at the North Carolina State Historic Preservation Office, Raleigh, NC, 1986.

Strauch, A. Bruce. "Narrative, Overhills History." On file at the Fort Bragg Cultural Resources Management Program, 2007.

"The Kent-Jordan-Lindley Enterprise in Hartnett and Cumberland," *Fayetteville Observer*, August 30, 1911.

Thomas, Joseph B. *Hounds and Hunting Through the Ages.* New York: The Derrydale Press, 1928.

Werling, Diana. "Historic American Landscape Survey Level One Recordation, Overhills, North Carolina." Submitted to the National Park Service. Gainesville, GA: The Jaeger Company, 2006.

Woodbury, Robert Louis. "William Kent: Progressive Gadfly, 1864–1928." New Haven, CT: Yale University, 1967.

ACROSS AMERICA, PEOPLE ARE DISCOVERING
SOMETHING WONDERFUL. THEIR HERITAGE.

Arcadia Publishing is the leading local history publisher in the United States. With more than 4,000 titles in print and hundreds of new titles released every year, Arcadia has extensive specialized experience chronicling the history of communities and celebrating America's hidden stories, bringing to life the people, places, and events from the past. To discover the history of other communities across the nation, please visit:

# www.arcadiapublishing.com

Customized search tools allow you to find regional history books about the town where you grew up, the cities where your friends and family live, the town where your parents met, or even that retirement spot you've been dreaming about.